ALBERT PALEY

SCULPTURE, DRAWINGS, GRAPHICS & DECORATIVE ARTS

Essay by
Craig Adcock

Florida State University Museum of Fine Arts
October 12 - November 18, 2001

Gulf Coast Museum of Art
February 15-April 14, 2002

Polk Museum of Art
April 27-July 23, 2002

Terrace Gallery, City of Orlando
January-April, 2003

Florida State University Museum of Fine Arts
School of Visual Arts & Dance

Albert Paley: Sculpture, Drawings, Graphics and Decorative Arts
was organized by the Florida State University Museum of Fine Arts
with grant assistance from the Florida Arts Council. Educational Programming is supported through the
Communiversity Partnership of the City of Tallahassee Cultural Services,
Cultural Resources Commission.

PROJECT SUPPORT
AND ORGANIZATION

Albert Paley: Sculpture, Drawings, Graphics and Decorative Arts was organized by the Florida State University Museum of Fine Arts. Project Curator, Grantwriter, Editor: A. Palladino-Craig. Registrar: Becky L. Jones; Museum Press Design—Julienne T. Mason; Fiscal Officer—Jean Young; Educational Programming—Viki D. Thompson Wylder; Preparator—Wayne Vonada.

This program is sponsored in part by the
State of Florida, Department of State,
Division of Cultural Affairs,
Florida Arts Council,
and the
National Endowment for the Arts.

Educational Programming for K-12 and
Seniors underwritten in part by grants
from the Communiversity Partnership
Tallahassee Cultural Services.

Cover and above: Details of *Florida State University Center Gates*, formed and fabricated steel, stainless steel, and bronze, 423 x 7 x 150 inches. Collection: Florida State University, Art in State Buildings Program, State of Florida, installed April 29, 1999. (Photograph: Bill Langford)

MUSEUM PRESS

Editor-in-Chief: A. Palladino-Craig
Graphic Design: Julienne T. Mason
Printer: Progressive, Jacksonville, FL.

THE *IMPRIMATUR* OF ALBERT PALEY

The Museum of Fine Arts offers deepest gratitude to the Artist and to his dedicated staff—particularly Eleta Exline and David Burdett. This complicated project has come together through their cheerful assistance and goodwill.

On this happy occasion, we have been privileged to work with Dr. Craig Adcock whose essay takes on one of the bipolar topics of contemporary art. Adcock's astute evaluation of the status of the art object today travels a long historical distance, concluding with the commentary of Albert Paley.

The Museum is also indebted to the Florida Arts Council for generous grant support of this exhibition that will be shared with the public of Florida at four institutions: MoFA in Tallahassee, the Gulf Coast Museum of Art in Largo, the Polk Museum of Art in Lakeland, and the Terrace Gallery of the City of Orlando.

For Albert Paley, the definitive turning point in his studio career—from metalsmithing on the intimate scale to fabrication on the monumental scale of public artworks—came in 1973 when he won the commission for the gates of the Renwick Gallery of the National Museum of American Art in Washington, D.C. *Albert Paley: Sculpture, Drawings, Graphics and Decorative Arts* is a spectrum of Paley's works, maquettes and proposals for major commissions, decorative arts, drawings, prints and sculpture: what each of these expressions has in common is the *imprimatur* of the Artist, the virtual thumbprint of his conceptual design.

Paley has set his creative mind and capable hand to a broad array of projects; these range from the 260-foot bridge railings for the Main Street Redevelopment Project of his home, Rochester, New York, to the interior sculptural ornament of a gilt opera box handle for a Texas cultural complex. The Artist orchestrates a team of professionals at the studio he incorporated in 1984 (he has had a substantial studio in New York with a growing team of assistants since 1972). He works from his original drawings and blueprints, making decisions to alter or ameliorate his design as he goes; enormous and powerful machinery is utilized, forging, shaping and manipulating elements to create Paley's titanic sculpture, heroic archways, massive gates, as well as human-scaled functional objects—ceremonial tables, desks, or lamps. Florida State University joins institutions like the Renwick Gallery (Smithsonian) and the New York State House (Albany) in its commission of ceremonial gates. Beneath the north-facing arch of University Center, Paley's *Stadium Gates* were installed in 1999.

Throughout his career, Paley has received numerous honors, among them a National Endowment for the Arts Visual Artist's Fellowship (1984); Gold Medals from the International Teaching Center of Metal Design in Aachen, Germany (1986 and 1991); the Art in Public Space Award, DFA Ltd. (1988); Honorary Doctorates of Fine Arts—from the State University of New York at Brockport, from St. Lawrence University, and from the University of Rochester, Rochester, New York (1989); the Preservation Award from the Preservation Alliance in Boston (1991); and an Artist's Fellowship from the New York Foundation of the Arts (1991). Paley Studios, Ltd., have produced such impressive architectural statements that in 1982 he was selected to win the Award of Excellence from the American Institute of Architects for Art in Architecture, specifically on the occasion of his *Portal Gates* for the New York Senate Chambers in Albany.

In addition to his municipal projects, such as the 1980 tree grates and park benches for the Pennsylvania Redevelopment Corporation in Washington, D. C., the dynamic, complementary pylons he named *Synergy* in 1987 (Museum Towers of Philadelphia) have become a signature work. Pairs of interior pylons completed in the same year for the Wortham Center for the Performing Arts in Houston, Texas, riffle in an imaginary wind, a steel metaphor of silken pennants with heights of fifteen to thirty feet and cantilevered metal ribbons that extend as far as twenty feet. Paley has journeyed from small scale in the seventies to his undertaking of a variety of commissions in the nineties—commissions like the sixty-foot tall monotone corten steel *Genessee Passage* for the Bausch & Lomb corporate headquarters in New York or the highly polychromatic *Olympia* for the Atlanta Promenade II Building; such works demonstrate that his eye for color or changing shadow is unequivocal, his reach and scale commanding. There seem to be no limitations at his studio, not in terms of dimension, surface patina or articulation. He has achieved that goal of all independent artists, producing superlative objects unlike any others, works that bear his distinctive *imprimatur*.

Allys Palladino-Craig
Director

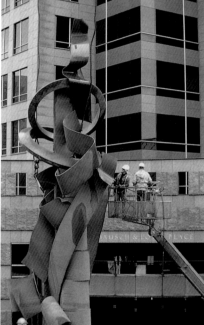

Albert Paley in his studio.
Installation of *Genesee Passage*, 1996, formed and fabricated weathering steel, Bausch and Lomb Corporate Headquarters, Rochester, New York, 720 x 192 x 244 and 60 x 156 x 156 inches. [*See page* 15.]

[*Top right*] *Pendant*, 1970, forged, fabricated, and oxidized silver and gold, with moonstones, tourmaline crystal, ivory, and seed, biwa, and baroque pearls, 13 1/2 x 7 1/2 x 2 1/2 inches. Private Collection. (Photograph: Bruce Miller)
[*Center right*] *Pin*, 1970, forged, fabricated, and oxidized silver, and gold, with labradorite, pearl, sand Brazilian tourmaline crystals, 7 1/2 x 8 x 1 3/4 inches. Private Collection. (Photograph: Bruce Miller)
[*Bottom right*] *Pendant*, 1972, forged and fabricated silver and copper, with glass, amethyst, faceted kunzite, kunzite crystals, and pearls, 5 3/4 x 1 1/2 x 16 1/2 inches. Private Collection. (Photograph: Bruce Miller)

ALBERT PALEY
Craig Adcock

Albert Paley produces well-crafted works ranging from jewelry to large-scale installations. His successful career was founded on the series of iron and bronze gates produced during the early 1970s, but he has also created furniture, decorative architectural screens, cast-iron grilles to protect trees along Pennsylvania Avenue in Washington, D.C., and monumental public sculptures. Paley works primarily in metal using a wide variety of techniques. He is especially well-known for his forging, an almost forgotten craft that he is largely responsible for reviving.[1] Paley is a metalsmith and a sculptor, and in both capacities, he relies upon his skill, his "art," in what is perhaps an earlier sense of the term "art." His pieces are always highly refined and difficult to make, and thus they require a great deal of "work," in what is perhaps also an earlier sense of the term "work."[2] With respect to the ambiguous meaning of such concepts, Paley has effectively crossed between the sometimes oppositional fields of art and craft. He produces craft objects that are art, and art objects that are craft. In the process, he actively engages in one of his most persistent arguments, namely, that the

conflict between art and craft is a false one.[3]

Paley's first mature works were jewelry. *Pendant* completed in 1970, is made of silver, gold, moonstones, tourmaline crystal, ivory, and pearls and measures over 13 inches long and over 7 inches wide. *Pin* also completed in 1970, is made of silver, 14 carat gold, moonstones, tourmaline crystal, and pearls and measures over 7 inches long and 8 inches wide. *Pendant* from 1972, is made of forged and fabricated sterling silver with copper inlay, and copper, with glass, amethyst, kunzite, and kunzite crystals and measures over 16 inches long and 6 inches wide. All of these pieces are much larger than we ordinarily expect pins and pendants to be, and, rather than refer to them as jewelry, we could better characterize them as small-scale sculptures.[4] They use the human body as a sculptural base, and the person wearing them provides the works with an ever-changing environment, a site that is not so much specific as personal. These characteristics suggest the metaphysical strengths of craft work, in general: they are as much haptic as visual, as much sensual as intellectual. They are embodiments of

1 Edward Lucie-Smith, *The Art of Albert Paley: Iron, Bronze, Steel* (New York: Abrams, 1996), 24-26.

2 For discussions of these terms, see Raymond Williams, *Keywords: A Vocabulary of Culture and Society* (New York: Oxford University Press, 1976), 32-35; 281-84; see also Roger Coleman, *The Art of Work: An Epitaph to Skill* (London: Pluto Press, 1988).

3 Lucie-Smith, 6, 173.

4 Most critics who have written about Paley's jewelry make this point; see Lucie-Smith, 16; see also the essays by Deborah L. Norton and Matthew Drutt in *Albert Paley: Sculptural Adornment*, exh. cat. (Washington, D.C.: Renwick Gallery of the National Museum of American Art, Smithsonian Institution; Seattle: University of Washington Press, 1991).

effort, and they touch upon a primal kind of understanding that is instantiated through the manipulation of material. As is perhaps true of all craft work, they must be worn, worn out, used, used up, felt. In short, they must be experienced, lived with, and not just comprehended abstractly.

Paley's jewelry shows the influence of his teacher Stanley Lechtzin[5] and other American jewelry makers associated with the post-World War II studio craft/art movement. In addition to Lechtzin, he often mentions such artists as Arline Fisch, Olaf Skoogfors, and John Prip as inspirations.[6]

Paley's jewelry can also be compared

to that of such historical figures as René Lalique and C. R. Ashbee, and his design sensibilities are especially close to those of Charles Rennie Mackintosh, Herbert MacNair, and their wives, Margaret Macdonald and Frances Macdonald.[7] Paley reinforced his own thinking by looking at these artists, and their examples helped him realize the unique vitality of craft. Although aware that modernist critics maintain that it is discursively limited, Paley is not convinced. He feels that craft can say a great deal. Although it may not involve itself with theoretical representation, it can express meaning, just like art. Indeed, its material presence in the here

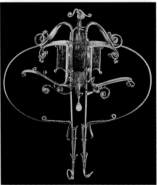

[5] Lechtzin's influence goes beyond formal concerns; see Paley's comments quoted by Deborah L. Norton, "The Jewelry of Albert Paley," in *Albert Paley: Sculptural Adornment*, exh. cat. (Washington, D.C.: Renwick Gallery of the National Museum of American Art, Smithsonian Institution; Seattle: University of Washington Press, 1991), 18: "He was the most demanding professor I ever had. He really stressed professionalism and insisted that students perform to the highest standards. I thrived under him. The greater the challenge and the more demands put on me, the more it suited me. And he was able to give perspectives and insights into the field of goldsmithing on a national and international level. The sculpture teachers really didn't do that. They were teaching aesthetics and technique. Stanley opened my eyes to the potential of the goldsmithing arena, so I was able to see how to work within it. He was a real mentor."

[6] Lucie-Smith, 16-23; see also Norton, 16. For a history of the post-World War II development of American craft, see Rose Slivka, "The Art/Craft Connection: A Personal, Critical, and Historical Odyssey," in *The Eloquent Object: The Evolution of American Art in Craft Media Since 1945*, exh. cat., ed. Marcia Manhart and Tom Manhart (Tulsa, Okla.: Philbrook Museum of Art, 1987), 67-103. Slivka was for many years the editor of *Craft Horizons*, one of the leading magazines devoted to contemporary craft. She argues that craft should become

more like art. For a telling critique of her underlying assumptions, and those of other writers in the catalogue, see Derek Guthrie, "'The Eloquent Object' Gagged by Kitsch," *New Art Examiner* 16 (September 1988): 26-29.

[7] As an important source for his awareness of such work, Paley cites Graham Hughes, *Modern Jewelry* (New York: Crown, 1963). Among the best discussions of C. R. Ashbee are Alan Crawford, *C. R. Ashbee: Architect, Designer & Romantic Socialist* (New Haven, Conn., and London: Yale University Press, 1985); see also Fiona MacCarthy, *The Simple Life: C. R. Ashbee in the Cotswolds* (Berkeley and Los Angeles: University of California Press, 1981). Good sources for René Lalique include Patricia Bayer and Mark Waller, *The Art of René Lalique* (London: Bloomsbury, 1988) and the recent exhibition catalogue *The Jewels of Lalique*, ed. Yvonne Brunhammer (Paris and New York: Flammarion, 1998). For a good general discussion of Art Nouveau, see Nancy Troy, *Modernism and the Decorative Arts in France: Art Nouveau to Le Corbusier* (New Haven, Conn., and London: Yale University Press, 1991); see also the essays in the handsome volume *Art Nouveau, 1890-1914*, ed. Paul Greenhalgh (New York: Abrams, 2000). A number of good discussions of Mackintosh and the other members of the "Glasgow Four" (Herbert MacNair, Margaret Macdonald, and Frances Macdonald) are included in *Charles Rennie Mackintosh*, exh. cat., ed. Wendy Kaplan (Glasgow: Glasgow Museums; New York:

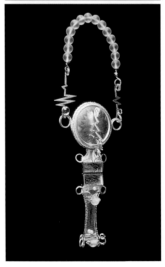

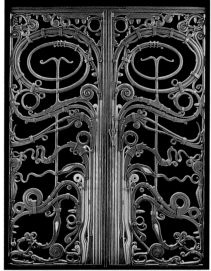

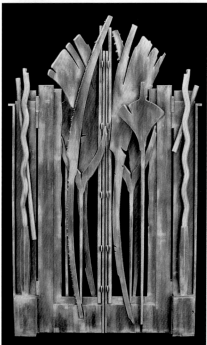

Portal Gates, 1974, forged and fabricated steel, brass, bronze, and copper, 72 x 4 x 90 1/4 inches. Renwick Gallery, Washington, D.C. (Photograph: Bruce Miller)

Ceremonial Gate, 1991, formed and fabricated, and painted steel, 100 x 18 x 167 1/2 inches. (Photograph: Bruce Miller)

and now allows it to speak in languages largely forgotten in Modernism.[8]

Paley's most renowned works are his *Portal Gates*. These gates, completed in 1974, are now installed at the Renwick Gallery of the National Museum of American Art, Smithsonian Institution, Washington, D.C. They are made of forged and fabricated steel, brass, bronze, and copper and measure 90 inches high, 72 inches wide, and 4 inches thick. Because gates are placed at openings between different spaces, they are often used symbolically to suggest movement from one state of being to another. They mark an edge or a boundary, and they thus carry the liminal associations of rites of passage.[9] This last function can be seen clearly in Paley's *University Center Gate*, installed in 1999 at Florida State University. This gate is formed and fabricated steel, stainless steel, and bronze. With a span of over 35 feet, rising to nearly 13 feet in height where the two sections meet and fasten, *University Center Gate* has always been a ceremonial portal, kept closed except for days when the stadium fills with as many as 80,000 visitors. Thresholds suggest not only rites

Abbeville Press, 1996). Also useful are Robert Macleod, *Charles Rennie Mackintosh: Architect and Artist* (London and Glasgow: Collins, 1983); Alan Crawford, *Charles Rennie Mackintosh* (London and New York: Thames and Hudson, 1995); and David Brett, *C. R. Mackintosh: The Poetics of Workmanship* (London: Reaktion Books, 1992). For a good general discussion of the Arts and Crafts Movement, see Gillian Naylor, *The Arts and Crafts Movement: A Study of Its Sources, Ideals and Influence on Design History* (Cambridge, Mass.: The MIT Press, 1971).

8 For useful discussions of the distinctive qualities of craft, see Larry Shiner, "Craft," *Encyclopedia of Aesthetics* (New York and Oxford: Oxford University Press, 1998), 1:450-53; see also N. C. M. Brown, "Theorizing the Crafts: New Tricks of the Trades," in *Craft and Contemporary Theory*, ed. Sue Rowley (St. Leonards, New South Wales, Australia: Allen and Unwin, 1997), 3-17; more traditional perspectives are expressed in R. G. Collingwood, *The Principles of Art* (Oxford: At the Clarendon Press, 1938) and V. A. Howard, *Artistry: The Work of Artists* (Indianapolis: Hackett, 1982).

9 For an interesting discussion of transitional experience, in general, see Victor W. Turner, *The Ritual Process: Structure and Anti-Structure* (Chicago: Aldine, 1969); idem, "Liminal to Liminoid, in Play, Flow, and Ritual: An Essay in Comparative Symbology," *Rice University Studies* 60 (1974): 53-92; idem, "Variations on a Theme of Liminality," in *Secular Ritual*, ed. Sally Moore (Leiden: Van

Gorcum, 1978), 27-41. Liminality also figures prominently in Victor Turner and Edith Turner, *Image and Pilgrimage in Christian Culture: Anthropological Perspectives* (New York: Columbia University Press, 1978). The concept of a "rite of passage" was first articulated in an important study originally published in 1908 by Arnold van Gennep, *The Rites of Passage*, trans. Monika B. Vizedom and Gabrielle L. Caffee (Chicago: University of Chicago Press, 1960).

10 This process was already underway in Cennino Cennini, *The Craftsman's Handbook* [c. 1390], trans. Daniel V. Thompson, Jr. (New Haven, Conn.: Yale University Press, 1933); excerpted in Elizabeth G. Holt, *A Documentary History of Art*, vol. 1: *The Middle Ages and the Renaissance* (Garden City, N.Y.: Doubleday, 1957), 148-49: "And let me tell you that doing a panel is really a gentleman's job, for you may do anything you want to with velvets on your back." As Holt points out, "velvets" would have been difficult and expensive to obtain in fourteenth-century Florence, and they would therefore have represented the "height of elegance." For histories of the changing status of artists during the Renaissance and later periods, see Anthony Blunt, "The Social Position of the Artist," in *Artistic Theory in Italy, 1450-1600* (London, Oxford, and New York: Oxford University Press, 1962), 48-57; see also Paul Oskar Kristeller, "The Modern System of the Arts: A Study in the History of Aesthetics," parts 1 and 2, *Journal of the History of Ideas* 12 (1951): 496-527; 13 (1952): 17-46.

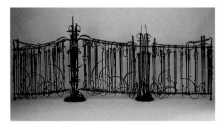

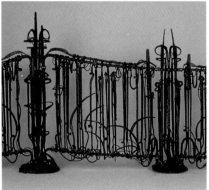

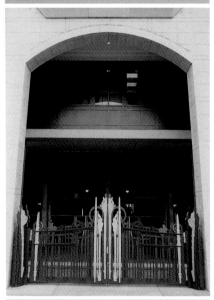

of passage, but also birth and the ultimate passage from life to death. In this last regard, they can also signal a rebirth into an afterlife as one might have it in the iconography of "gates of hell" or "gates of paradise." From this perspective, Paley's gates bring to mind similar portals in the history of art and craft such as Lorenzo Ghiberti's *Gates of Paradise*. Ghiberti's great doors were a consummate display of skill and diligence. They were also among the last high-level works to be completed before "art" and "craft" came to be differentiated in Renaissance and post-Renaissance theory.[10]

In addition to his gates, Paley has produced several closely related works that are also intended to divide space. For example, his *Architectural Screen*, done in 1983, is made of forged and fabricated steel and brass elements similar to those used in the gates. Paley's architecturally-scaled screen is a decorative object measuring over 19 feet long and over 7 feet high. Like the gates, Paley's partitions of this type function in the domain of "craft,"

but they cross over into the domain of "sculpture." For this reason, they raise questions that center precisely on the distinctions that we have come to expect in post-Renaissance discussions of "art" and "craft."[11] As our descriptions of *Portal Gates*, *Ceremonial Gate*, and *Architectural Screen* may indicate, the terms "art" and "craft" are complex and difficult to use. For one thing, when the term "craft" is applied to these kinds of work, it seems misleading or inadequate, especially if its pejorative connotations are allowed to cloud its meaning.

Significantly, the negative overtones of the word "craft" are related to the way it has been used historically, and the often belittling insinuations implied by it reflect the embeddedness of that usage in the art world. As suggested earlier, the contemporary art world holds craft work or hand work (sometimes called handicraft) inferior to art work or brain work (sometimes called thinking). High-level intellectual activity is given precedence over low-level practical activity.[12] Raymond Williams, among oth-

11 T. R. Martland, "Art and Craft: The Distinction," *British Journal of Aesthetics* 14 (1974): 231-38; Charles B. Fethe, "Craft and Art: A Phenomenological Distinction," *British Journal of Aesthetics* 17 (1977): 129-37; Harold Osborne, "The Aesthetic Concept of Craftsmanship," *British Journal of Aesthetics* 17 (1977): 138-48.

12 Such attitudes are reflected in the following remarks by Peter Dormer, "The Ideal World of Vermeer's Little Lacemaker," in *Design After Modernism: Beyond the Object*, ed. John Thackara (New York: Thames and Hudson, 1988), 141: "Craft does not have intellectual connotations. True enough, the craftsperson has a position, but it is perceived as rural, reactionary, hidebound, skill-oriented and rooted in the ethics of toil and conservatism. This may be unfair, and it is certainly arbitrary. But what is and what is not 'Art'

is decided by the art world and so, without the acceptance of the art world, the concept of the artist-craftsperson will have no currency and has no currency beyond the pages of the crafts magazines." The most famous discussion of the role of the art world in defining "art," is Arthur Danto, "The Artworld," *Journal of Philosophy* 61 (1964): 571-84; see also his later elaboration of these ideas in *The Transfiguration of the Commonplace: A Philosophy of Art* (Cambridge, Mass.: Harvard University Press, 1981); also relevant is George Dickie, *Art and the Aesthetic* (Ithaca, N.Y., and London: Cornell University Press, 1974); for one of the more interesting critiques of Danto's argument, see Pierre Bourdieu, "The Historical Genesis of a Pure Aesthetic," trans. Channa Newman, *The Journal of Aesthetics and Art Criticism* 46 (1987): 201-10. For an interesting counter to the "mind" versus "body" argument that is commonly

[*Top and center*] *Architectural Screen*, 1983, forged, twisted, punched, wrapped, and riveted steel and brass, 90 x 234 x 24 inches. (Photograph: Bruce Miller)

[*Bottom*] *Florida State University Center Gates*, formed and fabricated steel, stainless steel, and bronze, 423 x 7 x 150 inches. Collection: Florida State University, Art in State Buildings Program, State of Florida, installed April 29, 1999. (Photograph: Bill Langford)

ers, has traced the history of this formulation. He points out, in *Keywords*, that it was only during the nineteenth century that the differential process initiated in the Renaissance culminated in "art" being reserved to designate, almost exclusively, painting, sculpture, and the other fine arts.[13] In earlier times, a person's "art" was simply his or her job, the activity in which he or she was engaged to make a living.[14] The tendency to elevate art into a special category of work, with its attendant theories of genius and creativity, was reinforced during subsequent centuries to account for the special qualities of art. These qualities, as we now know them, came to be associated with the invention of radically new forms and patterns, and craft came to be associated with the repetition of established forms and patterns.[15] During the course of the separation of innovation and application,

complex distinctions between artists and artisans, between designers and fabricators, and between painters, sculptors, and craftsmen were confirmed and incorporated into criticism as virtual dogma. This dogma is the familiar one that underlies Modernist theory.

In modern art practice and usage, distinctions came more and more to be made between the various people who produce work: there were, it was argued, important differences between "artists," "scientists," "engineers," "artisans," "craftsmen," and "skilled laborers." Williams, again in *Keywords*, has astutely pointed out that all these categories are defined in terms of the way work is organized:

As these practical distinctions are pressed, within a given mode of production, art and artist acquire ever more general (and

more vague) associations, offering to express a general human (i.e. non-utilitarian) interest, even while, ironically, most works of art are effectively treated as commodities and most artists, even when they justly claim quite other intentions, are effectively treated as a category of independent craftsmen or skilled workers producing a certain kind of marginal commodity.[16]

Contemporary craftspractitioners operate within these complicated fields of distinction. Like fine artists, they produce fine objects, which, like works of art, are prone to becoming commodities.[17]

The Industrial Revolution exacerbated the conversion of various categories of work. It also contributed to the separation of various components of a single category of work, one from the other, most generally

found in analyses of "art" versus "craft," see Sue Rowley, "Mind Over Matter? Reading the Art/Craft Debate," *West* 1, no. 1 (1989): 3-5; see also Arthur Danto, "Fine Art and the Functional Object," *Glass* 51 (Spring 1993): 24-29.

[13] Williams (cited n. 2), 33.

[14] Of course, things are never all that "simple." The relationship women have had with crafts throughout the centuries is complicated by gender issues. For illuminating histories, see Josephine Donovan, "Everyday Use and Moments of Being: Toward a Nondominative Aesthetic," in *Aesthetics in Feminist Perspective*, ed. Hilde Hein and Carolyn Korsmeyer (Bloomington and Indianapolis: Indiana University Press, 1993), 53-67; Christine Battersby, *Gender and Genius: Towards a Feminist Aesthetic* (London: The Women's Press, 1989). Correlations between modernist defamation of craft and exclusion of women has been examined by feminists; see Rozsika Parker and Griselda Pollock, "Crafty Women and the Hierarchy of the Arts," in *Old Mistresses: Women, Art*

and Ideology (New York: Pantheon, 1981); also Lucy Lippard, *Mixed Blessings: New Art in Multicultural America* (New York: Pantheon, 1990). Art versus craft issues are also complicated along postcolonial lines, and it should be remembered that the western denigration of craft is not a universal phenomenon; see, for example, the essays collected in *The Necessity of Craft: Development and Women's Craft Practices in the Asian-Pacific Region*, ed. Lorna Kaino (Nedlands: University of Western Australia Press, 1995); also relevant are the discussions in Bill Ashcroft, Gareth Griffiths, and Helen Tiffin, *The Empire Writes Back: Theory and Practice in Post-Colonial Literatures* (London and New York: Routledge, 1989).

[15] See Umberto Eco, *The Limits of Interpretation* (Bloomington and Indianapolis: Indiana University Press, 1990), 83-84.

[16] Williams (cited n. 2), 34-35.

[17] Williams, 283-84; see also, Paul Wood, "Commodity," in *Critical Terms for Art History*, ed. Robert S.

Nelson and Richard Shiff (Chicago and London: University of Chicago Press, 1996), 257-80. Among the more interesting discussions of the strange life of commodities are Wolfgang Fritz Haug, *Critique of Commodity Aesthetics: Appearance, Sexuality and Advertising in Capitalist Society*, trans. Robert Bock (Cambridge: Polity Press, 1986) and Jean Baudrillard, *For a Critique of the Political Economy of the Sign*, trans. Charles Levin (St. Louis, Mo.: Telos Press, 1981). John Perreault addresses these issues in a clever article, "Crafts Is Art: Notes on Crafts, on Art, on Criticism," in *The Eloquent Object: The Evolution of American Art in Craft Media Since 1945*, exh. cat., ed. Marcia Manhart and Tom Manhart (Tulsa, Oklahoma: Philbrook Museum of Art, 1987), 189-201.

[18] Debates about "art" versus "design" in many ways parallel those involving "art" versus "craft." Good discussions are included in *Design and Aesthetics: A Reader*, ed. Jerry Palmer and Mo Dodson (London and New York: Routledge, 1996). Palmer, in his introduction (p. 3), points out that "any definition of 'design' is likely to be controversial, and partial,

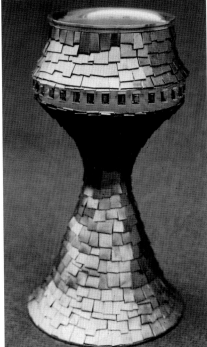

along assembly lines. As assembly lines came to be powered by steam engines, and very soon thereafter, by internal combustion engines and electricity, progress came to be measured in terms of efficiency. Mechanical reproduction also made it possible to distort basic relationships within work and to alienate the method of production from the things it produced. A single worker was no longer responsible for the entire production of an object, from conceptualization to realization. By separating the mind from the hand, industrial capitalism could all the more readily cooperate in the estrangement of skill from work. Division of labor served to segregate thinking from making and to distinguish design, a lofty mental profession, from production, a lowly physical job.[18] In the process, crafted objects became manufactured goods, and precious things became commodities. The free-floating nature of such products allowed them to be manipulated by advertising and marketing strategies.

At this juncture in history, one does not have to go so very far to encounter a situation in which the products of art and art criticism are likewise commodities. In the circumstances that obtain in western market economies, work can be separated into various fields of activity, and these can range from factory work to studio work. They can also be made to fall out along a continuum from debased to revered, from ordinary to extraordinary. Throughout modernity, thought of here as a period roughly corresponding to the rise of industrial capitalism, say 1780 to 1950,[19] art and craft have become more and more differentiated. During this period, there have also been notable attempts to bring them together. Walter Gropius, in his manifesto for the founding of the Bauhaus, published in 1919, exhorted his followers to embrace traditional methods:

> Architects, painters, sculptors, we must all return to the crafts! For there is no such thing as "professional art." There is no essential difference between the artist and the craftsman. The artist is an exalted craftsman. By the grace of Heaven and in rare moments of inspiration which transcend the will, art may unconsciously blossom from the labor of his hand, but a foundation of handicraft is essential for every artist. It is there that the primary source of creativity lies. Let us therefore create a new guild of craftsmen

and that this is so for reasons intrinsic to the subject: in a nutshell, the boundary between 'art' and 'design' is always necessarily fluid insofar as all artifacts can be said to have elements of both in them, whether the artifacts in question are conventionally classified as 'art objects' or 'design object.' This is necessarily so because all objects have a function of some sort by virtue of occupying some place in human society (this might include the function of being rejected as 'worthless' or 'foul,' which reinforces the evaluative boundary of usefulness and worthiness), and all objects have to be created according to some imaginative process where the creator imagines them in their completed state before completion occurs in actuality. This points to ambiguities in the definition of the terms 'design' and 'art.'" We could easily substitute the word "craft" for "design" in the above remarks.

19 Raymond Williams, *Culture and Society*, 1780-1950 (New York: Harper and Row, 1966).

Chalice, 1969, forged, fabricated, and oxidized sterling silver with gold gilt and synthetic tourmalines, 5 inches diameter x 12 inches. Private Collection. Albert Paley, 1970, first studio.

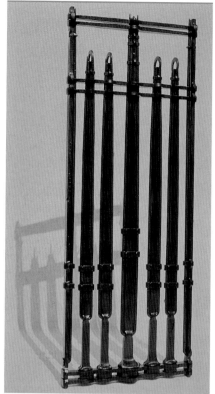

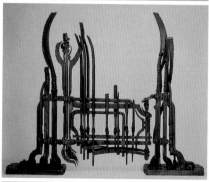

without the class distinctions that raise an arrogant barrier between craftsman and artist! Let us together desire, conceive and create the new building of the future, which will combine everything—architecture and sculpture and painting—in a single form which will one day rise towards the heavens from the hands of a million workers as the crystalline symbol of a new and coming faith.[20]

But Gropius's attitude is something of an exception. Modernist aesthetics has more generally associated artistic progress with innovation, and in this regard, it shares much in common with science. Clement Greenberg apparently had this correlation in mind when he made the following observation:

That visual art should confine itself exclusively to what is given in visual experience, and make no reference to anything given in other orders of experience, is a notion whose only justification lies, notionally, in scientific consistency. . . . From the point of view of art itself, its convergence of spirit with science happens to be a mere accident, and neither art nor science gives

or assures the other of anything more than it ever did. What their convergence does show, however, is the degree to which Modernist art belongs to the same historical and cultural tendency as modern science.[21]

In the course of the twentieth century especially, art has progressed, according to such arguments, in terms of paradigm shifts analogous to the ones that take place in science. In both domains, change proceeds in a positive direction on the basis of new discoveries. A new art form is thus analogous to a new scientific law or scientific principle.[22]

Paley's particular brand of innovation complicates this forward-looking way of making art, one that progresses in terms of new results and breakthroughs. He proceeds by looking backward, by renewing what has been forgotten or suppressed. His gates and his other architectural projects return to some of the fundamental sources of modernism, sources that are all too often overlooked in celebrations of the new. It should be remembered that decoration is an important part of the modernist tradition and that the works of such artists as Hector Guimard, Antoni Gaudí, and Victor Horta are as much a part of the collection of the Museum of Modern Art as more rarefied forms of abstraction. Paley's gates and ornamental screens recall

20 Walter Gropius, "Manifesto and Programme of the Bauhaus, Weimar, April, 1919," in *The Bauhaus: Masters & Students by Themselves*, ed. Frank Whitford (London: Conran Octopus, 1992), 38; for examples of craft objects produced at the Bauhaus, see Walther Scheidig, *Crafts of the Weimar Bauhaus, 1919-1924: An Early Experiment in Industrial Design* (New York: Reinhold, 1967).

21 Clement Greenberg, "Modernist Painting," in *The New Art: A Critical Anthology*, ed. Gregory Battcock (New York: Dutton, 1966), 107-8.

22 Eco (cited n. 15), 83.

the Art Nouveau masterpieces of these artists. Guimard and Gaudí are particularly germane to his work because they worked so effectively with the integration of iron decorations into the structural fabric of buildings. One thinks especially of Guimard's railings and gates for the Paris Métro, 1899-1904, and Gaudí's ironwork gates for the Güell Palace in Barcelona, 1894-99. Perhaps most evocative of Paley's approach are the works of Horta, as seen, for example, in the Hôtel Solvay in Brussels, 1895-1900. One can also recall, again, the relevance of Charles Rennie Mackintosh. In this context, the Scottish designer's wrought-iron lamp brackets for the Glasgow School of Art, 1897-99, and his doors for the Willow Tea Rooms, 1904, can be seen as important precursors of Paley's decorative works.[23]

Because Paley's embellishment programs return to earlier traditions, they can be thought of as conservative. Paley, of course, argues that what his works conserve is fundamentally important. Craft allows the artist to retain an aspect of work that often disappears in modern production; it is an aspect that is more fully stated in the related German word "kraft," meaning "power" or "force."[24] Craft, in this sense, can give a work a dimension of excellence that cannot be achieved otherwise. Paley aspires to the kind of physical and structural excellence that is associated with the nineteenth-century Arts and Crafts movement. He believes

that respect for materials and sound working methods can produce more substantial results than might otherwise be the case, and he tries to give his works a character of being well-made, something that he feels adds to their aesthetic strength. He is very much interested in what is put into the work by the effort used to make it: "the forms I've developed, the vocabulary I've dealt with, are very hand-intensive. They take a lot of skill, but more of a nineteenth-century skill. A fabricator couldn't do it. Or even if he could, it would be so expensive that it would be out of the question. So, rather than change my aesthetic to that required by commercial fabrication, I looked for ways around the problem. I built machines myself to do certain jobs, and I trained my own people. It became very much more like a nineteenth-century craft atelier, with a team working together."[25]

Among the most prominent items of Paley's "craft atelier" are furnishings.[26] His designs combine function and decorative purpose. They are forged and fabricated with techniques similar to those used in the gates and architectural screens, and they conform to the same high standards of workmanship. Like the gates and screens, the furniture is very ornate, recalling Art Nouveau precursors. The whiplash lines of metal, undulating in and out of space, echo the behavior of growing plants, but the various elements are not precisely "vegetal" as they might be in Art Nouveau

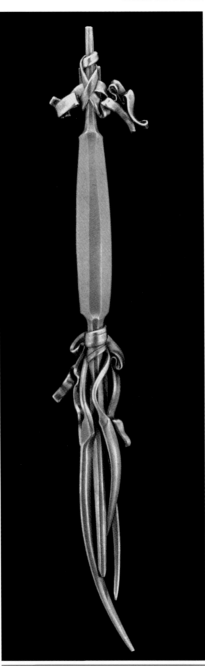

Opera Box Handle, 1987, cast bronze, 3 x 4 x 19 inches, Wortham Center for the Performing Arts, Houston, Texas. Collection of Dr. Metzger. (Photograph: Bruce Miller)

23 The classic discussion of Art Nouveau as a precursor to Modernism is Nikolaus Pevsner, *The Sources of Modern Architecture and Design* (London: Thames and Hudson, 1968).

24 Cf. Slivka (cited n. 6), 84.

25 Albert Paley, quoted in Edward Lucie-Smith, *The Art of Albert Paley: Iron, Bronze, Steel* (New York: Abrams, 1996), 77.

26 Lucie-Smith, 40-53.

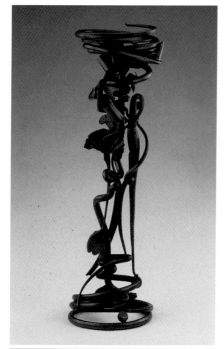

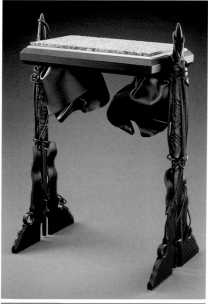

Plantstand, 1990, forged and fabricated steel, with slate top, 58 x 23 x 17 inches.
Presentation Table, 1998, forged and fabricated steel, copper, with granite top, 40 x 22 x 51 1/2 inches. Private Collection. (Photograph: Bruce Miller).

designs. In other words, Paley's works are exuberant, but, in general, they retain something of the rectilinear structure of the stock steel, the bronze or brass plate and rod from which they are made.[27] A typical example is *Plantstand*, 1990. This work is made of forged and fabricated steel and is just under 5 feet tall. It seems to restate the organic in slightly inorganic terms. Another design is *Presentation Table*, 1998, made of forged and fabricated steel with copper and a carved granite top. This table measures 40 inches wide, 51 1/2 inches high, and 22 inches deep. In terms of its sheer decorative vitality, the table goes well beyond being a simple piece of "furniture." To be sure, it has use value, as does the plant stand discussed earlier, but it also has display value. The forms of these objects not only follow their functions, they celebrate them and restate them metaphorically.

Paley's design sensibilities can be seen in another interesting group of useful objects that were done in 1981. He was commissioned by the City of Washington, D.C., to design grates for the trees planted along Pennsylvania Avenue. These works also function in harmony with their

purpose, while holding their own as decorative objects. The grates are constructed of cast iron, and they were produced by a contractor. They are thus something of an exception to Paley's general hands-on working method. By serving only as the designer, he was unable to contribute directly to the individual character of the specific grates. These manufactured works thus lack the particular sense of facture, the quality called *manifattura* in Italian, that he generally gives to his objects. As can be seen here in the slippery way that connotative meaning moves around in related terms like "facture" and "manufacture," reversed in the Italian "*manifattura*," workmanship raises interesting questions, both specifically in terms of Paley's oeuvre, and more generally in terms of the "art" versus "craft" debate.[28]

Because Modernist theory considers that art objects are unique, while craft objects are examples of a prototype, it supposes that there is a similarity between craft production and industrial production. There can be as many examples of any given prototype as the craftsperson wishes, and consequently the craftsperson,

27 There are some interesting exceptions to this rule; Paley's design for the Central Park zoo gate, 1985, for example, is more representational than the majority of his works; for a discussion of this gate, see Lucie-Smith, 67-70.

28 Manufacture, of course, comes from the Latin "manus," meaning hand, and "factus," the past participle of "facere," meaning "to make." The Italian "manifattura" comes from the same roots, but has retained its connotation of hand work more than the English. Bourdieu (cited n. 10) uses the word in this sense (p. 205): "That is why, among all the inventions which accompany the emergence of the field of production, one of the

most significant is probably the elaboration of an artistic language. This involves first establishing a way of naming the painter, of speaking about him and about the nature of his work as well as of the mode of remuneration for his work, through which is established an autonomous definition of properly artistic value irreducible to the strictly economical value and also a way of speaking about painting itself, of pictorial techniques, using appropriate words (often pairs of adjectives) which enable one to speak of pictorial art, the *manifattura*, that is, the individual style of the painter whose existence it socially constitutes by naming it."

as a producer of nearly identical examples of a given work, is analogous to a machine in a factory that produces many virtually identical versions of a design. The industrial process uses a model to effect duplicates or facsimiles of an "original," but this "original" may consist only of a plan or a set of instructions. At the highest levels of result, the products of designers who set up machine assembly-line processes, manufacturing processes, can be valued for their qualities, but such products, according to modernist aesthetic theory, are rarely thought of as "art," and the processes themselves are not understood as being "artistic." The replication of standard types and the low regard in which such practice was held in post-Renaissance theory also explains why the products of mass culture are similarly denigrated. Such works as television programs, movies, comic books, and pulp fiction novels are basically duplicates of prototypes.[29] That such products are popular is also a mark against them because popularity presumably implies that standards have been compromised in order to satisfy an audience, an audience that may know what it likes, but does not have the capacity to discriminate.[30]

When Marcel Duchamp emphasized the "serial characteristics" of his readymades, he returned the modernist

prejudice for originality back to its origin and revealed some of the problems involved in "discrimination." Had not a fundamental distinction come to exist between art and craft, his gesture would not have been understood, much less have had any shock value. By baptizing mass-produced objects "art," he introduced products back into the domain of aesthetic debate that had become anathema to the notion of artistic invention. This gesture allowed him to challenge the status quo: "Properly, any masterpiece is called that by the spectator as a last resort. It is the onlooker who makes the museum, who provides the elements of the museum. Is the museum the final form of comprehension, of judgment?"[31]

Both Duchamp and Paley would no doubt answer this question in the negative. Both artists were dissatisfied with the way things were when they found them. Paley turns his back on current prejudices about art and craft and returns to such traditional working methods as forging. His revolutionary approach, which like Duchamp's throws down a theoretical gauntlet at the foundations of Modernism, can perhaps be more easily seen in his sculpture. Paley's large-scale work is decorative, and in this sense, not unlike his other work. In other words, his non-functional sculpture is informed by the same formal qualities that

Drawing of Tree Grate for Pennsylvania Avenue, Washington, D.C., graphite on paper, 31 1/2 x 24 inches. Collection: Katrina and Carlos Mercado. (Photograph: Bruce Miller)
 Tree Grate, 1981, cast iron, 88 inches diameter, Pennsylvania Avenue Development Corporation, Washington, D.C.
 Bench and Tree Grate, 1981, cast iron, 88 inches diameter, Pennsylvania Avenue Development Corporation, Washington, D.C.

29 Eco (cited n. 15), 83-84.

30 Among interesting discussions of the issues raised here are Pierre Bourdieu, *Distinction: A Social Critique of the Judgement of Taste,* trans. Richard Nice (Cambridge, Mass.: Harvard University Press, 1984); Andreas Huyssen, *After the Great Divide: Modernism, Mass Culture, Postmodernism* (Bloomington and Indianapolis: Indiana University Press, 1986);

Andrew Ross, *No Respect: Intellectuals and Popular Culture* (New York and London: Routledge, 1989); and Guy Brett, *Through Our Own Eyes: Popular Art and Modern History* (London: GMP, 1987).

31 Marcel Duchamp interviewed by Pierre Cabanne, *Dialogues with Marcel Duchamp,* trans. Ron Padgett (New York: Viking, 1971), 70.

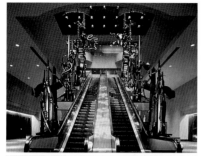

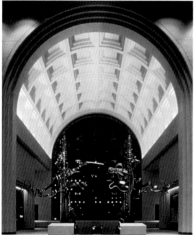

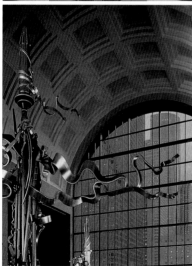

Stairway Sculptures, 1987, formed, fabricated, and painted steel, 264 x 60 x 336 inches. Wortham Center for the Performing Arts, Houston, Texas. (Photograph: Hester & Hardaway, Fayetteville, Texas)

characterize his jewelry, his gates and screens, his furniture, and his protective tree grates. All of his works, from his pins and pendants to his gates and plant stands, are marked by decorative flourishes. So are his more monumental projects. Because they too are decorative, these works raise similar kinds of philosophical questions, particularly insofar as decoration was imprecated according to the minimalist strictures that informed much of the sculpture that was being produced contemporaneously with Paley's.

Among Paley's most important sculptural programs are the *Stairway Sculptures*, completed in 1987, for the Wortham Center for the Performing Arts in Houston, Texas. There are four pairs of these sculptures, all made of formed, fabricated, and painted steel. They seem to ascend into the space, flanking the escalator in the foyer of the building. These progressively more flamboyant works rise in a kind of crescendo, becoming taller and more elaborate as the viewer rides up the escalator. The two sculptures in the lowest part of the space are approximately 15 feet tall, and those at the top are approximately 30 feet tall. The *Stairway Sculptures* demonstrate one of Paley's guiding principles: he endeavors to make his public installations relate to their settings. Here, his works, his sculptural performances, suggest victory and celebration. The barrel-vaulted space of the foyer suggests the intrados of a Roman triumphal arch, and the sculptures themselves resemble Roman standards, the implements of power that were carried by the Emperor in triumphal processions.[32]

Another example of Paley's public sculpture is *Genesee Passage*, 1996. This work is made of weathered fabricated steel. It consists of two parts, a large element that measures 60 feet high, 16 feet deep, and 20 feet wide, and a small element that measures 5 feet high and 13 feet in diameter. These are installed in front of the corporate headquarters of Bausch and Lomb, Inc., in Rochester, New York. The principal upright element consists of a split column. The design, with its references to architecture, is meant to symbolize the City of Rochester and its relationship with the Genesee River.[33] Undulating forms, like vertical sections of the column, are placed between the column halves and further suggest the interdependence of the city and the river. At the top of the column are off-set rings intertwined with a large ribbon or banner. This overall assembly makes up the principal part of the sculpture and is aligned with the central axis of the building's main façade. The smaller element of the work is placed on a flanking area of the split-level plaza and resembles a column base surmounted by two segments of undulating forms. These components again suggest the river and how it has historically contributed to the growth of the city. Like the *Stairway Sculptures*, *Genesee Passage* plays a celebratory role. Both of its elements are flourishes of complex architectural and heraldic reference that mark the entrance to the building. At this level, the two-part sculpture functions like one of Paley's gates, with each part working like a hinge that articulates the space of the plaza. At another level, the sculpture decorates the architecture of the site in

32 Lucie-Smith (cited n. 1), 70-73.

33 Lucie-Smith, 166.

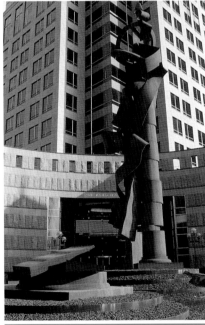

much the way jewelry decorates the human body.[34]

As these remarks indicate, distinguishing between "major" and "minor" arts is by no means a straightforward act of applying universally agreed-upon aesthetic criteria. Especially during the twentieth century, both artists and craftspractitioners have reappraised the status of "works of art." Paley has interrogated the underlying assumptions of abstraction and decoration, as he explains in relation to one of his jewelry designs (see works on pages 5, 15, 30, and 52):

> Here you have crystals, which are raw material with a certain character and uniqueness—color, refraction, texture, etc.—and they are placed next to a geometrically pure, highly polished industrial object so one plays off the other. Not creating a hierarchical judgment but letting them exist side by side—and with their existence creating an environment that made all things plausible—had a lot to do with my own personal philosophy. That rejection of hierarchical perception was a way to justify my own development within the

ongoing battle between fine arts and minor arts. I felt that it was solely through creativity and personal investigation that one could aspire to break through the limitations placed on crafts.[35]

Paley, when he made these remarks, must have been feeling somewhat beleaguered, but he was not alone in his struggles. In Futurism, Dadaism, and Constructivism, and in broad-minded educational institutions such as the Bauhaus, and also in their contemporary successors, the roles played by "art" and "craft" in aesthetic practice have often been complicated almost beyond recognition. Avant-garde movements and programs, as opposed to high modernist ones, have continued to question the notion of "originality" and the necessity of not duplicating what has already been done. This alternative tradition brushes against the grain of Modernism, and it informed at least part of the art world that was in operation during Paley's formative years.[36]

Umberto Eco points out that "much art has been and is repetitive. The concept of absolute originality is a contemporary one, born with Romanticism; classical art was in vast measure serial, and the 'modern' avant-garde (at the beginning of

34 Edward Lucie-Smith has also suggested a correlation between Paley's jewelry and his sculpture; see his "Beyond Ornamentation—The Sculptured Jewelry of Albert Paley," in *Albert Paley: Sculptural Adornment,* exh. cat. (Washington, D.C.: Renwick Gallery of the National Museum of American Art, Smithsonian Institution; Seattle: University of Washington Press, 1991), 11-12.

35 Paley quoted by Norton (cited n. 5), 20.

36 This is Walter Benjamin's famous phrase; see his "Theses on the Philosophy of History," in *Illuminations,* ed. Hannah Arendt, trans. Harry Zohn (New York: Schocken Books, 1969), 256-57: "There is no document of civilization which is not at the same time a document of barbarism. And just as such a document is not free of barbarism, barbarism taints also the manner in which it was transmitted from one owner to another. A historical materialist therefore dissociates him

Pendant, 1972, copper, gold, glass, Delrin, 5 1/2 x 3 x 16 inches. Private Collection.

Genesee Passage, 1996, formed and fabricated weathering steel, Bausch and Lomb Corporate Headquarters, Rochester, New York, 720 x 192 x 244 and 60 x 156 x 156 inches. (Photograph: Bruce Miller)

this century) challenged the romantic idea of 'creation from nothingness,' with its techniques of collage, mustachios on the Mona Lisa, art about art, and so on."[37] During the course of the twentieth century, the roles of "art" and "craft," with their respective associations of "uniquity" and "commonality," have often been reversed or turned completely upside down. Duchamp's manufactured objects chosen as ready-made works of art are perhaps the most notorious upendings of the presuppositions of modernist aesthetics. He points out that the word "art" was originally related to the act of making something: "The idea of the artist as a sort of superman is comparatively recent. This I was going against. In fact, since I've stopped my artistic activity, I feel that I'm against this attitude of reverence the world has. Art, etymologically speaking, means 'to make.' Everybody is making, not only artists, and maybe in coming centuries there will be the making without the noticing."[38]

Duchamp's speculations are hopeful to the point of being unrealistic. Ernst Bloch, the philosopher who has given us our most profound discussions of utopia offers a more positive approach to the future than many of his contemporaries.[39] In postmodern times, utopian narratives have become increasingly difficult to believe. As Stephen Eric Bronner puts it, such schemes "have lost their appeal; socialism and utopia can now only take the form of a regulative idea."[40] In an age of doubt, we no longer trust in the desirability of regulative ideas. But, despite our reservations, Bloch's ideas are still relevant because what we may have gained in philosophical sophistication, we pay for in increased skepticism. Our disbelief occludes any horizon of possibility, and without seeing a purpose, life seems dark. Against this obscurity, Bloch's ideas continue to shed some light: he was interested in asking what it meant to strive for a better way of life, and for him, the primary justification of philosophy was to help in such inquiries. He believed that utopian dreams could advance our quest for a better reality.

Utopias have concerned themselves with establishing a more perfect order, eliminating human conflict, and living a more balanced life. They are, in general, orthodox and tend to be seen by their detractors as uncomfortably restrictive, but in Bloch's work, utopias can be open-ended and allow for all manner of promise. Utopias are often dismissed as mere "hankerings after the impossible," al-though as Vincent Geoghegan has pointed out, "this limited definition is often used in the service of highly subjective definitions of realism, where interests and ideologies determine what, supposedly, can or cannot be achieved." Rather than being inevitably impractical, he argues, utopias "*can* be both rational and feasible."[41] Bloch's work falls into this category. His dreaming was sophisticated and generous, and it was also realistic. Paley's art has comparable properties. Despite the fact that it can be associated with conservative practices, his work breaks out of the limits written into the rules of modernist art. In this sense, it dreams of other ways of doing things. Like Bloch's unfinished nowhere that refuses to place a boundary around the human prospect, Paley's art hopes for something more, for something different that has not yet to come to pass. Across the horizon of that future, perhaps it will be recognized that there is no need to differentiate between art and craft; or to use Duchamp's words again, "maybe in coming centuries there will be the making without the noticing."

As the present discussion suggests, making without noticing would not necessarily indicate any disregard. It could rather embody an ideal recognition of

self from it as far as possible. He regards it as his task to brush history against the grain." See also Terry Eagleton, *Against the Grain: Essays 1975-1985* (London: Verso, 1986), and idem, *Walter Benjamin, or Towards a Revolutionary Criticism* (London and New York: Verso, 1981).

[37] Eco (cited n. 15), 95.

[38] Marcel Duchamp interviewed by Frances Roberts, "I Propose to Strain the Laws of Physics," *Art News* 67 (December 1968): 62.

[39] Bloch's magnum opus is *The Principle of Hope*, 3 vols., trans. Neville Plaice, Stephen Plaice, and Paul Knight (Oxford: Blackwell, 1986); also useful in this context are his *Spirit of Utopia*, trans. Anthony A. Nassar (Stanford, Calif.: Stanford University Press, 2000) and the essays collected in *The Utopian Function of Art and Literature*, trans. Jack Zipes and Frank Mecklenberg (Cambridge, Mass., and London: The MIT Press, 1988). For an interesting discussion of Bloch's life and work, see Vincent Geoghegan, *Ernst Bloch* (London and New York: Routledge, 1996).

[40] Stephen Eric Bronner, "Utopian Projections: In Memory of Ernst Bloch," in *Not Yet: Reconsidering Ernst Bloch*, ed. Jamie Owen Daniel and Tom Moylan (London and New York: Verso, 1997), 165-66.

[41] Vincent Geoghegan, "Remembering the Future," in *Not Yet: Reconsidering Ernst Bloch*, ed. Jamie Owen Daniel and Tom Moylan (London and New York: Verso, 1997), 15.

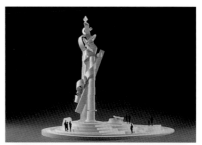

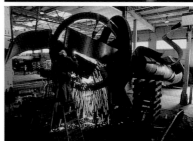

human capacity. Paley uses metal in decorative modalities to connect with tradition, but also to articulate the present. He creates objects that are tactile as well as visual, that are worn, occupied, passed through, and experienced as spatial clarifications. He releases the potentiality of mere substance into actuality.[42] His works, from his jewelry and furniture, to his gates and public sculpture, define relationships. His works are made with hands that function at arms's length from the body; they are not placed at a remove, at a distance configured solely by vision. His works are thus intimate, whatever their scale, and they are profoundly material. For this reason, they call forth the practices and possibilities that have been erased in modernist preoccupations with aesthetic autonomy. Paley's works reassert his working methods. His materials and his techniques bear witness to judgments arrived at through the direct application of know-how. His assiduous labor lays down a pattern of precision in the structure of the metal he shapes. We read this pattern as necessary. We see within it, we feel within it, an expression of our need to have well-made things around us, a basic desire that relates to what it means to be alive. Paley's form recapitulates the subtlety of his expertise. He is among a group of modern masters who refuse to accept the

customary discriminations that have split the so-called "minor" arts away from the "major" arts. Post-Renaissance art theory, and modern art history and criticism, have been complicit in rending apart what was once a seamless whole. But modernity is an atypical period. Throughout most of human history, and prehistory for that matter, art and life have been woven together in one fabric. Paley in this sense is a fabricator, a re-weaver, a maker who establishes a place for art, who opens an opportunity for craft, where beauty can enter into the ordinary routines of living and into the ordinary things that surround us. —C.A.

Craig Adcock, School of Art and Art History, University of Iowa, has published works on Marcel Duchamp, James Rosenquist, and James Turrell, including *Marcel Duchamp's Notes from the Large Glass* (Ann Arbor, Mich.: UMI Research Press, 1983), *James Rosenquist* (Tallahassee: Florida State University Museum of Fine Arts, 1988), and *James Turrell, The Art of Light and Space* (Berkeley and Los Angeles: University of California Press, 1990). Professor Adcock has held positions in the Art History Departments of Florida State University and the University of Notre Dame. He is the author of numerous exhibition catalogues and articles and has recently published *Judy Ledgerwood: Cold Days* (Chicago: The Renaissance Society, University of Chicago, 1999).

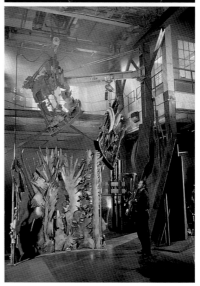

42 The philosophical framework being suggested here recalls Martin Heidegger's craft-oriented discussions of "being" and "bringing-into-being"; see, for example, his "Age of the World Picture," in *The Question Concerning Technology and Other Essays*, trans. William Lovitt (New York: Harper and Row, 1977), 115-54; and "Building Dwelling Thinking," in *Poetry, Language, Thought*, trans. Albert Hofstadter (New York: Harper and Row, 1971), 145-61.

[*Top*] *Genesee Passage*, maquette of sculpture for Bausch and Lomb Corporate Headquarters, Rochester, New York, 1994, formed, fabricated, and painted foam core, wood and steel, 66 x 44 x 50 inches. (Photograph: Bruce Miller)

[*Center*] Paley studio. Production of *Genesee Passage*.

[*Bottom*] Albert Paley with *Sculpture*, 1993, formed and fabricated steel, polychromed, Mitchell H. Cohen Federal Courthouse, Camden, New Jersey, 107 x 67 x 12 inches.

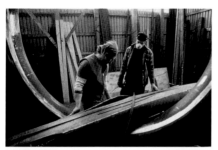

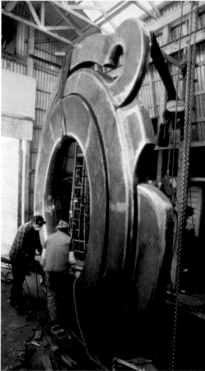

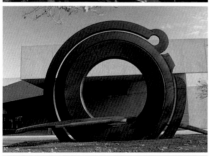

Construction and installation view of *Strong Museum Sculpture*, 1982, fabricated cor-ten steel, Rochester, New York, 378 x 72 x 186 inches. (Photograph: Bruce Miller).

SELECTED PERMANENT COLLECTIONS

American Craft Museum, New York, New York

Art Gallery of Western Australia, Perth, Australia

The Birmingham Museum of Art, Birmingham, Alabama

The British Museum, London, England

The Columbus Museum of Art, Columbus, Ohio

Cooper-Hewitt, Smithsonian Institution, Washington, D.C.

Delaware Art Museum, Wilmington, Delaware

Detroit Institute of Arts, Detroit, Michigan

Earlham College, Richmond, Indiana

The Fitzwilliam Museum, Cambridge University, England

Gannett Publishing Corporation, Washington, D.C.

Grace Episcopal Church, Scottsville, New York

High Museum of Art, Atlanta, Georgia

Hunter Museum of Art, Chattanooga, Tennessee

International Sculpture Center's Collection II

Memorial Art Gallery, University of Rochester, Rochester, New York

Metropolitan Museum of Art, New York, New York

Minnesota Museum of American Art, St. Paul, Minnesota

Mint Museum of Craft and Design

Museum of Art, Brigham Young University, Provo, Utah

Museum of Fine Arts, Boston, Massachusetts

Museum of Fine Arts, Springfield, Massachusetts

The Museum of Fine Arts Houston, Houston, Texas

The Newark Museum, Newark, New Jersey

Philadelphia Archdiocese, Philadelphia, Pennsylvania

Philadelphia Museum of Art, Philadelphia, Pennsylvania

Renwick Gallery, Smithsonian Institution, Washington, D.C.

Strong Museum, Rochester, New York

Temple University, Philadelphia, Pennsylvania

Toledo Museum of Art, Toledo, Ohio

University of Illinois, Normal, Illinois

Virginia Museum of Fine Arts, Richmond, Virginia

The White House, Washington, D.C.

Victoria & Albert Museum, London, England

Worcester Art Museum, Worcester, Massachusetts

Wustum Museum of Fine Art, Racine, Wisconsin

Yale University Art Gallery, New Haven, Connecticut

[*Top right*] Construction of *Portal Gates*.

[*Center and bottom right*] Albert Paley, *Portal Gates*, 1980-1981, forged and fabricated steel/brass/bronze, 108 x 6 x 162 inches, New York State Senate Chambers, Albany, New York. (Photograph *in situ*: Kenneth M. Hay)

MAJOR COMMISSIONS

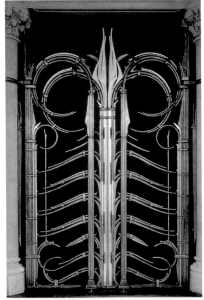

1975　Hunter Museum of Art, Chattanooga, Tennessee. *Sculpture Court Enclosure*, exterior sculpture. Forged and fabricated steel, painted. 6 to 12 feet H x 87 1/2 feet W.

1976　Gannett Corporation, Inc., Corporate Headquarters, Rochester, New York. *Fireplace Hood*. Forged and fabricated steel, copper plated. 132 inches H x 78 inches W x 36 inches D. Architects: Burwell, Bantell Architects, Rochester, New York.

1977　Columbia Bank, Gates, New York. *Lighting Fixture*, interior sculpture. Forged and fabricated steel. 10-1/2 inches H x 7-1/2 inches D.

1978　Redevelopment Authority of the City of Philadelphia, Philadelphia, Pennsylvania. *Security Screens*. Forged and fabricated steel. 6 feet H x 4 feet W; *Two Gates*. Forged and fabricated steel. 3 feet H x 8 feet W. Architects: Louis Sauer Associates, Philadelphia, Pennsylvania.

1979　Clyde's Restaurant, Tyson's Corner, Virginia. *Pergola, Banisters, and Railings*. Forged and fabricated painted steel and bronze. *Push Plates* for revolving doors. Cast bronze. Dimensions very, interior and exterior installation.

1980　Prospect Place, Washington, D.C.

Clock, exterior clock. Forged, fabricated and painted steel, brass, and bronze. 13 feet 5-1/2 inches H x 4 feet 10 inches D. Architects: Metcalf and Associates, Washington, D.C.

New York State Senate, Albany, New York for State Senate Chambers, Capitol Building. Two pair *Portal Gates*. Forged and fabricated steel, brass, and bronze. 162 inches H x 108 inches W x 6 inches D each.

1981　Edward J. Lenkin, Washington, D.C. *Entrance Gate*. Forged and fabricated steel, painted. 12 feet H x 7 feet W.

Pennsylvania Avenue Redevelopment Corporation, Washington, D.C. Eight hundred *Tree Grates*. Cast iron. 88 inches diameter. Thirty *Benches*. 68 inches diameter.

1982　Edward J. Lenkin, Washington, D.C. *Vehicular Gate*. Forged and fabricated steel, painted. 8-1/2 feet H x 8-1/2 feet W.

Strong Museum, Rochester, New York. *Sculpture*, exterior sculpture. Hollow formed and fabricated Cor-ten steel. 15-1/2 feet H x 31-1/2 feet W x 6 feet D.

1983　Clyde's Restaurant, Tyson's Corner, Virginia. *Fountain*. Forged and

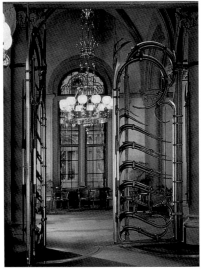

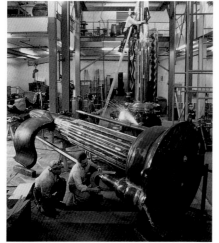

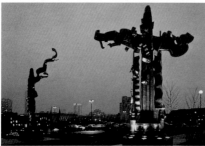

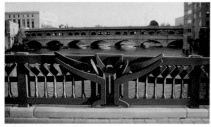

Construction of *Synergy*, 1987. (Photograph: Bruce Miller)

Albert Paley, *Synergy*, 1987, forged and fabricated steel, polychromed, 648 x 36 x 300 inches, Museum Towers, Philadelphia, Pennsylvania. (Photograph: Tom Crane)

Albert Paley, railing and installation of *Bridge Railing Project*, 1989, forged and fabricated steel, monochromed, 360 x 18 x 42 inches, Main Street, Rochester, New York. (Photograph: Bruce Miller)

fabricated painted steel, brass, carved slate, and glass, 13 feet H x 12 feet W x 4 feet D.

Frederick Merritt Gallery, Rochester, New York. *Entrance Gate*. Forged and fabricated steel. 7 feet H x 6 feet W.

The Hyatt Corporation, for the Hyatt Grand Cypress Hotel, Orlando, Florida. *Stair Enclosure*. Forged and fabricated steel and brass. 19-1/2 feet H x 8-1/2 feet W x 7-7/8 feet D.

Quadrangle Development, for the J. W. Marriott Hotel, Washington, D.C. *Gates*. Forged and fabricated steel and brass, 8 feet H x 6 feet W. *Architectural Screen*. Forged and fabricated steel. 5 feet H x 25 feet W.

1984 Harro Theater East, Rochester, New York. *Conclave*, exterior sculpture. Formed and fabricated steel, painted. 30 feet H x 22 feet W x 10 feet D.

Port Authority of Allegheny County, Pennsylvania for the Light Rail Transit System of Pittsburgh. *Poster Cases*. Formed and fabricated steel, painted. 8-1/2 feet H x 4-1/2 feet W.

1985 Virginia Museum of Fine Art, Richmond, Virginia. *Pedestrian Entrance Gate*. Forged and fabricated steel, painted. 8 feet H x 8 feet W. *Vehicular Entrance Gate*. Formed and fabricated steel,

painted. 11-1/2 feet H x 32 feet W. Architects: Hardy, Holzman & Pfeiffer, New York, New York.

The Willard Building, Washington, D.C. *Sculpture*, interior sculpture. Forged and fabricated steel and brass. 8 feet 2 inches H x 5 feet 11 inches W x 1 feet 6 inches D. *Door Pulls*. Cast bronze. 24 inches H x 19 inches W x 3 inches D. Architect: Valstimil Koubeck, Washington, D.C.

1986 Gannett Publishing Corporation, Washington, DC. *Bronze Wall Relief*. Forged and fabricated bronze. 6 feet H x 15 feet W x 1 foot D. Architects: Burwell-Bantell Architects, Rochester, New York.

New York State Council on the Arts, New York, New York. *New York State Governor's Art Awards*. Forged and fabricated steel. 18 inches H x 4 inches D.

1987 Houston Lyric Theater Foundation, Inc., Houston, Texas, for the Wortham Center for the Performing Arts. Eight *Stairway Sculptures*, interior sculptures. Formed and fabricated steel, polychromed. Varying in height from 15 feet to 30 feet. *Door Pulls and Pushes*. Cast bronze. 28 inches H x 36 inches W. Architects: Morris Architects, Houston, Texas (formerly Morris Aubry Architects).

Massachusetts Bay Transit Authority, Milk Street Station, Boston, Massachusetts. *Entrance*

Gateway. Forged and fabricated steel, painted. 10 feet H x 10 feet W.

Redevelopment Authority of the City of Philadelphia for Museum Towers, Philadelphia, Pennsylvania. *Synergy*, archway exterior sculpture. Formed and fabricated steel, painted. 25 feet H x 60 feet W x 6 feet D. Architects: Salkin Group, Philadelphia, Pennsylvania.

1988 Cornell University Medical College, Lasdon Biomedical Research Building, New York, New York. *Window Screen*, interior sculpture. Forged and fabricated steel, painted. 8 feet W x 6 feet H x 1 foot D. Architects: Payette Associates, Boston, Massachusetts.

Memorial Art Gallery of the University of Rochester, Rochester, New York. *Convergence*, interior sculpture. Forged and fabricated steel, painted. 8 feet H x 6 feet W x 3 feet.

State of Connecticut, Bureau of Public Works, for the Hartford Superior Court Building, Hartford, Connecticut. *Hexad*, interior sculpture. Forged and fabricated painted steel, brass. 21 feet H x 12 feet D.

Washington Hebrew Congregation, Washington, D.C. Two *Menorahs*. Forged and fabricated painted steel. 8 feet H x 6 feet W

x 3 feet D. *Flower Stands*, forged and fabricated painted steel. 36 inches H x 26 inches D. *Sconces*, cast bronze. 30 inches H x 18 inches W x 9 inches D.

1989 City of Rochester, New York, Main Street Redevelopment Project. *Bridge Railings*, forged and fabricated painted steel. 41 inches H x 8 inches D x 260 feet L.

Naples/Marco Philharmonic Building, Naples, Florida. *Door handles*, forged and fabricated naval bronze. 24 feet L x 8 feet H x 1 foot D. Architect: Eugene Aubry, Aubry Associates.

1990 The Landmarks Group, Promenade Two Building, Atlanta, Georgia. *Olympia*, exterior sculpture. Formed and fabricated steel, polychromed. 29 feet H x 14 feet W x 8 feet D. Architect: Thompson, Ventulett, Stainback & Associates, Inc., Atlanta, Georgia.

Arts Council of Roanoke Valley, Roanoke Airport Authority. Roanoke Regional Airport, Roanoke, Virginia. *Aurora*, exterior sculpture. Forged and fabricated steel, polychromed. 18 feet H x 12 feet W x 6 feet D.

Birmingham Museum of Art, Birmingham, Alabama. *Confluence*, exterior sculpture. Formed and fabricated Cor-Ten steel, 18 feet H x 10 feet W x 4 feet D.

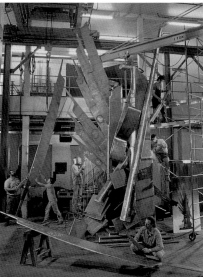

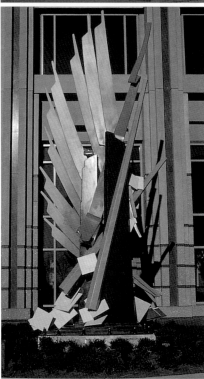

Construction of *Olympia*. (Photograph: Bruce Miller) Albert Paley, *Olympia*, 1990, forged and fabricated mild steel, 144 x 96 x 360 inches, AT&T Promenade II, Atlanta, Georgia. (Photograph: John Dale)

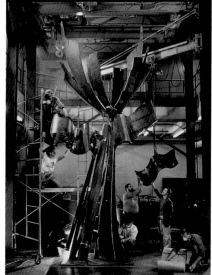

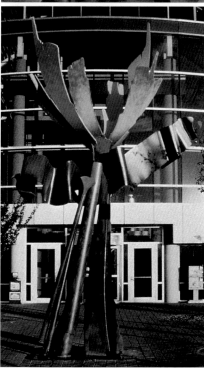

Construction of *Aurora*. (Photograph: Bruce Miller)
Albert Paley, *Aurora*, 1990, forged and fabricated
steel, polychromed, 144 x 96 x 240 inches, Roanoke
Airport, Roanoke, Virginia. (Photograph: David Diaz
Guerrero)

1991 Arizona State University, Phoenix
 Campus. *Ceremonial Gates*, exterior sculpture. Formed and fabricated steel, polychromed. Phoenix, Arizona. 12 feet H x 8 feet W x 1-1/2 feet D. Architect: Coover, Saemisch, & Anderson.

1992 Montgomery County, Silver Springs, Maryland. *Criss-Cross*, exterior sculpture. Formed and fabricated steel, polychromed. 20 feet H x 30 feet W x 10 feet D.

1994 General Services Administration, Washington, D.C. for the Federal Courthouse, Camden, New Jersey. *Metamorphosis*, interior sculpture. Formed and fabricated steel, polychromed. 107 inches H x 134 inches W x 18 inches D.

 Temple Israel, Dayton, Ohio. *Tabernacle Screen*. Formed and fabricated steel, polychromed. 91.5 inches H x 104 inches W x 4 inches D. Architects: Hardy, Holzman & Pfeiffer, New York.

 Victoria & Albert Museum, London, England. *Museum Bench*. Fabricated steel, mahogany. 27 inches H x 135 inches W x 30 inches D.

1995 General Services Administration, Washington, D.C. for the New Federal Building, Asheville, North Carolina. *Passage*, exterior sculpture. Formed and fabricated, weathering steel. 37 feet H x 23 feet W x 16 feet D.

1996 Bausch and Lomb, Rochester, New York, for the new corporate headquarters. *Genesee Passage*, exterior sculpture. Formed and fabricated, weathering steel. 720 inches H x 192 inches W x 144 inches D.

 San Francisco Art Commission, California, for the Civic Center Courthouse. *Exterior Entrance Doors, Rotunda Lobby Gates, Elevator Doors and Elevator Handrail Brackets*. Formed and fabricated stainless steel.

 Sony Pictures Entertainment, Culver Studios Office Building, Culver City, California. *Primordial Reflections*, security screens. Formed, fabricated and painted steel. 80 inches H x 257 inches W x 10 inches D.

 Congregation Adath Jeshurun, Elkins Park, Pennsylvania. *Revelation*, set of sliding screens. Formed and fabricated steel. 293 inches H x 153 inches W x 39 inches D.

 Temple Israel, Dayton, Ohio. *Eternal Light and Menorahs*. Formed and fabricated steel, polychrome.

1997 San Francisco Art Commission, California, for the Civic Center Courthouse. *Exterior Entrance Doors, Rotunda Lobby Gates, Elevator Doors and Elevator Handrail Brackets*. Formed and fabricated stainless steel.

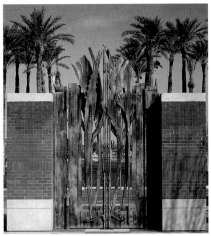

The Ohio State University, Columbus, Ohio. *Gnomon*, exterior sculpture. Formed and fabricated weathering steel, natural patina. 235 inches H x 103 inches W x 95 inches D.

Canandaigua Wine Company, Canandaigua, New York. *Helix*, exterior sculpture. Formed and fabricated weathering steel, natural patina. 192 inches H x 180 inches W x 462 inches D.

American Bankers Insurance Group, Miami, Florida. *Exterior Sculpture*. Formed and fabricated steel, polychrome. 211 inches H x 100 inches W x 65 inches D.

Victoria and Albert Museum, London, England. *Benefactors' Wall Sculptures*, honorary awards. Formed and fabricated steel. 15 inches H x 16.5 inches W x 1.5 inches D.

Miami University, Oxford, Ohio. *Door Handles*, door handles for Alumni Hall. Formed and fabricated bronze. 73 inches H x 11 inches W x 4 inches D.

Congregation Adath Jeshurun, Elkins Park, Pennsylvania. *Flower Urns*. Formed and fabricated steel, bronze. 65 inches x 36 inches diameter.

1998 Adobe Systems, Inc., San Jose, California. *Horizon*, exterior sculpture, water fountain and lighting features for plaza complex.

Formed and fabricated weathering steel, stainless steel, bronze, natural patina. 336 inches H x 444 inches W x 84 inches D /108 inches H x 84 inches W x 90 inches D.

The Municipality of Anchorage, Anchorage, Alaska. *Solstice*, exterior sculpture. Formed and fabricated steel, stainless steel, natural patina and polychrome. 307 inches H x 102 inches W x 90 inches D.

The University of Toledo, Toledo, Ohio. *Symbion*, exterior sculpture. Formed and fabricated weathering steel, stainless steel, natural patina and polychrome. 333 inches H x 140 inches W x 96 inches D.

Temple Israel, Dayton, Ohio. *Menorah*. Formed and fabricated steel, stainless steel. 45 inches H x 21 inches W x 108 inches D.

1999 Florida State University, Tallahassee, Florida. *Stadium Gates*. Formed and fabricated steel and stainless steel. 150 inches H x 432 inches W x 7 inches D.

The Toledo Museum of Art, Toledo, Ohio. *Confluence*, design of meeting and banquet space including sideboards, sconces, and mirrors. Formed and fabricated stainless steel.

Private residence, Admiral's Cove, Florida. *Front Entrance Gates*.

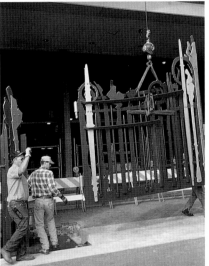

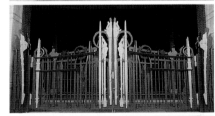

Ceremonial Gate, 1991, formed and fabricated, and painted steel, 100 x 18 x 167 1/2 inches, Arizona State University. (Photograph: Richard Maack)

Florida State University Center Gates, formed and fabricated steel, stainless steel, and bronze, 423 x 7 x 150 inches. Collection: Florida State University, Art in State Buildings Program, State of Florida, installed April 29, 1999. (Photograph: Bill Langford)

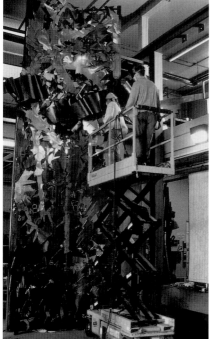

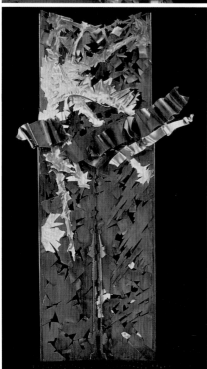

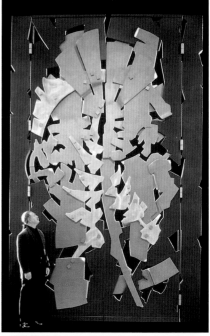

Formed and fabricated steel. 166 inches H x 226 inches W x 25 inches D.

2000 University of the South, Sewanee, Tennessee. *Monumental Gates*. Formed and fabricated steel. 99 inches H x 168 inches W x 6 inches D.

Naples Philharmonic Center for the Arts, Naples Florida. *Portal Gates*. Formed and fabricated steel, stainless steel, and bronze. 242 inches H x 128 inches W x 16 inches D.

Monahan Pacific Development Corporation, San Francisco, California. *Lighting and Main Entrance Portal*. Formed and fabricated stainless steel.

Eastman Kodak Company, Rochester, New York. *Diversity Award Sculpture and Medallions*.

2001 Florida Gulf Coast University, Fort Myers, Florida. *Cross Currents*, exterior sculpture. 262 inches H x 143 inches W x 96 inches D.

The Commission Project, Rochester, New York. J D *Award Sculpture and Personalized* J D *Award Sculptures*.

[*Top left*] Construction of *Revelation*. (Photograph: Bruce Miller)

[*Bottom left*] Albert Paley, *Revelation*, 1996, formed and fabricated steel, bronze, Congregation Adath Jeshurun, 153 x 39 x 293 inches. (Photograph: Bruce Miller)

[*Above*] Construction of *Portal Gates*. (Photograph: Bruce Miller)

Albert Paley, *Portal Gates*, 2000, formed and fabricated steel, stainless steel, Naples Art Museum, Florida, 127 1/2 x 16 x 241 1/2 inches. (Photograph: Bruce Miller)

GATES

Florida State University Center Gates, formed and fabricated steel, stainless steel, and bronze, 423 x 7 x 150 inches. Collection: Florida State University, Art in State Buildings Program, State of Florida, installed April 29, 1999.

Gate Section from proposal for the Central Park Zoo, New York, 1987, forged and fabricated Cor-ten steel, with gold leaf, 75 x 66 x 166 inches. Private Collection.

ARCHITECTURAL APPOINTMENTS

Door Handles, 1985, cast bronze, 19 x 3 x 24 inches, The Willard Building, Washington, D.C.

Façade Door Handles, 1987, cast bronze, 36 x 4 x 28 inches, Wortham Center for the Performing Arts, Houston, Texas.

CANDLEHOLDERS

Millennium Candleholders, 1999, formed and fabricated steel, 5 1/4 inches diameter x 17 1/2 inches. Private Collection.

Menorah, 1999, formed and fabricated steel, brass, 20 3/4 x 5 1/4 x 9 1/2 inches. Private Collection.

JEWELRY

Penannular Brooch, 1969, forged, fabricated, and oxidized bronze, with silver, gold, rutilated quartz, gold inlay, and garnet, 3 7/8 x 2 7/8 x 5 7/8 inches. Private Collection.

Sectional Brooch, 1969, silver, gold, moonstones, pearls, 3 1/2 x 1 1/4 x 8 1/2 inches. Private Collection.

Brooch, 1971, silver, gold, moonstone, pearls, glass, 5 x 3 x 6 1/2 inches. Private Collection.

Pendant, 1973, forged, fabricated, and formed silver, copper and gold, with antique cameo, pearls, and Delrin, 4 1/2 x 41/2 x 17 inches. Private Collection.

Pendant, 1973, forged and fabricated silver, gold, and copper, with Delrin, glass, and opal, 7 1/2 x 2 5/8 x 21 inches. Private Collection.

FUNCTIONAL WORKS

Lectern, 1986, forged and fabricated steel and brass, 24 x 18 x 48 inches. Private Collection.

Splayed Bench, 1992, forged and fabricated steel, with mahogany seat, 126 x 35 x 70 inches. Private Collection.

Cocktail Table, 1992, forged and fabricated steel, with glass top, 46 inches diameter x 15 3/4 inches. Private Collection.

Oasis, 1994, formed and fabricated steel and stainless steel with mahogany top, 109 1/2 x 19 1/2 x 54 inches. Private Collection.

LAMPS

Millennium Floor Lamp, 1999, formed and fabricated stainless steel with glass shade, 29 1/2 inches diameter x 75 inches. Private Collection.

Dragon's Back Table Lamp, 1999, formed and fabricated steel with glass shade, 20 1/4 inches diameter x 26 1/2 inches. Private Collection.

Corona Lamp, 1999, formed and fabricated steel with glass shade, 19 inches diameter x 38 inches. Private Collection.

Dragon's Back Floor Lamp, 1992, forged and fabricated steel, with glass shade, 36 inches diameter x 80 inches. Private Collection.

MAQUETTES AND PROPOSALS

Traverse, maquette of sculpture for San Diego, California, 1996, formed and fabricated steel and stainless steel (polychromed), 22 x 19 x 40 1/4 inches.

Portal, maquette of Irish Famine Memorial for Philadelphia, Pennsylvania, 1997, formed and fabricated steel, stainless steel, stone, 35 1/2 x 60 1/2 x 15 inches.

Odyssey, maquette of sculptural archway for Florida State University, Tallahassee, Florida, 1996, formed and fabricated steel, 11 1/2 x 7 x 30 inches (each).

Maquette of sculpture for Eastern Connecticut State University, 1998, 18 x 11 x 26 1/2 inches.

SCULPTURE

Hector, 1990, forged, fabricated, and painted steel, 31 1/4 x 23 x 104 inches. Private Collection.

Chrysalis, 1996, formed and fabricated steel, stainless steel, 107 inches x 20 inches diameter. Private Collection.

Bronze Vessel, 1999, cast bronze, 14 x 10 x 45 inches. Private Collection.

Tangent, 1999, formed and fabricated steel and copper; cast glass, 23 x 14 1/2 x 27 1/8 inches. Private Collection.

Twisted Arc, 2000, forged, twisted, and fabricated steel; clear glass, 32 x 26 x 33 1/2 inches. Private Collection.

JD Award Sculpture, 2001, formed and fabricated steel, 23 inches diameter x 86 inches. The Commission Project, Rochester, New York.

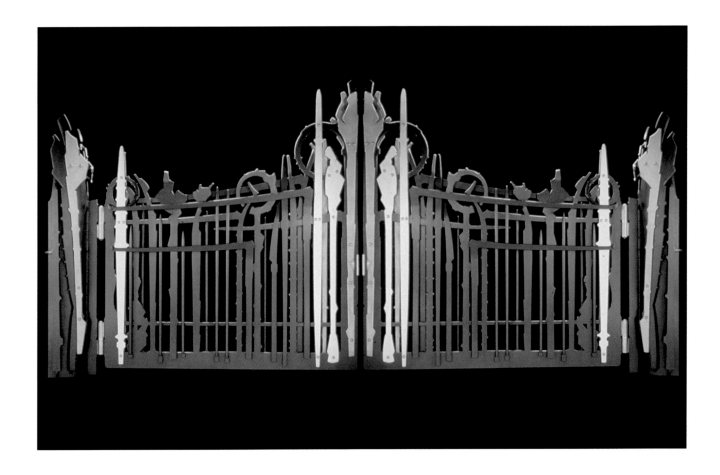

Florida State University Center Gates, formed and fabricated steel, stainless steel, and bronze, 423 x 7 x 150 inches. Collection: Florida State University, Art in State Buildings Program, State of Florida, installed April 29, 1999. (Photograph: Bruce Miller)

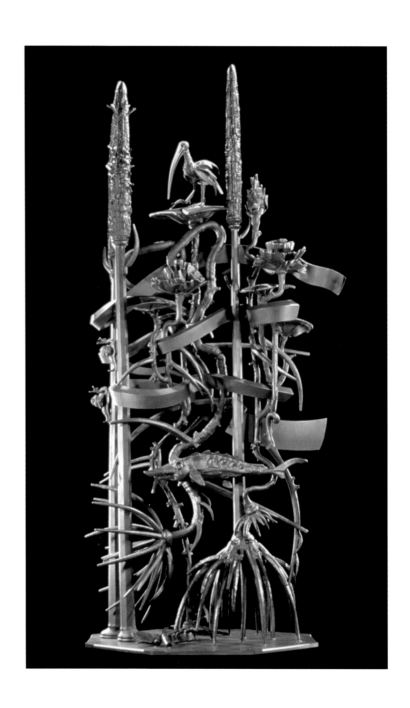

Gate Section from proposal for the Central Park Zoo, New York, 1987, forged and fabricated Cor-ten steel, with gold leaf, 75 x 66 x 166 inches. Private Collection. (Photograph: Bruce Miller)

Facade Door Handles, 1987, cast bronze, 36 x 4 x 28 inches,
Wortham Center for the Performing Arts, Houston,
Texas. (Photograph: Bruce Miller)

Door Handles, 1985, cast bronze, 19 x 3 x 24 inches, The
Willard Building, Washington, D.C. (Photograph: Bruce
Miller)

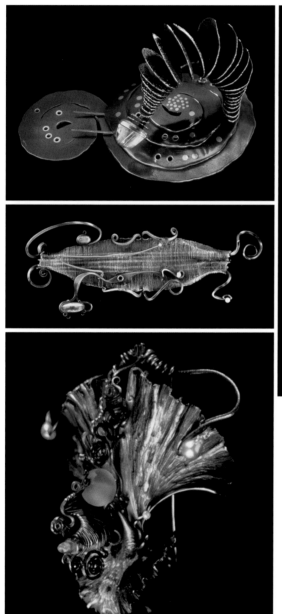

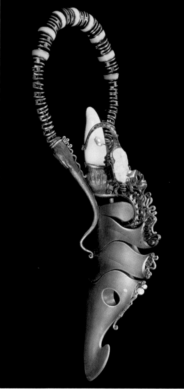

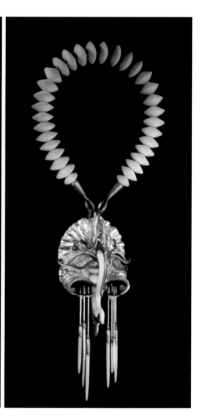

[*Top left*] *Penannular Brooch*, 1969, forged, fabricated, and oxidized bronze, with silver, gold, rutilated quartz, gold inlay, and garnet, 3 7/8 x 2 7/8 x 5 7/8 inches. Private Collection. (Photograph: Bruce Miller)

[*Center left*] *Sectional Brooch*, 1969, silver, gold, moonstones, pearls, 3 1/2 x 1 1/4 x 8 1/2 inches. Private Collection.

[*Bottom left*] *Brooch*, 1971, silver, gold, moonstone, pearls, glass, 5 x 3 x 6 1/2 inches. Private Collection.

[*Above left*] *Pendant*, 1973, forged, fabricated, and formed silver, copper and gold, with antique cameo, pearls, and Delrin, 4 1/2 x 4 1/2 x 17 inches. Private Collection.

[*Above right*] *Pendant*, 1973, sterling silver, 14K gold, gold inlay, copper, opal, glass, Delrin, 15 x 6 x 3 inches. Private Collection. (Photograph: Bruce Miller)

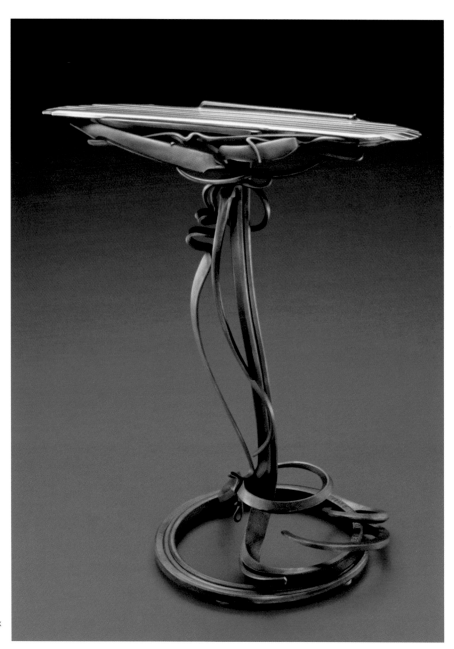

Lectern, 1986, forged and fabricated steel and brass, 24 x 18 x 48 inches. Private Collection.

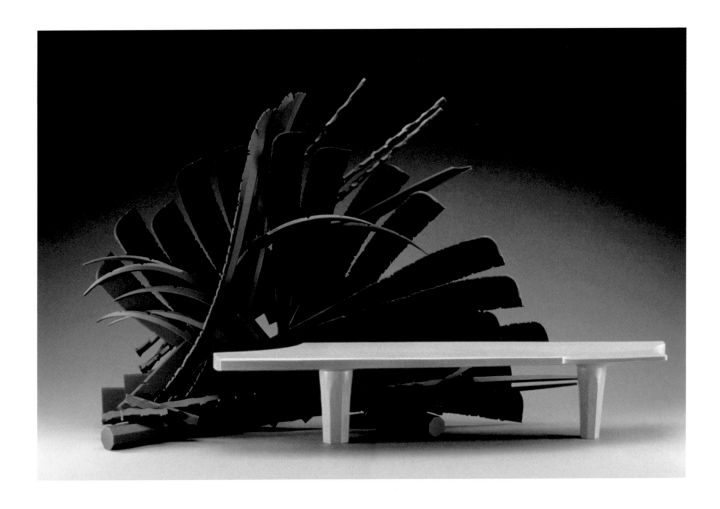

Splayed Bench, 1992, forged and fabricated steel, with mahogany seat, 126 x 35 x 70 inches. Private Collection. (Photograph: Bruce Miller)

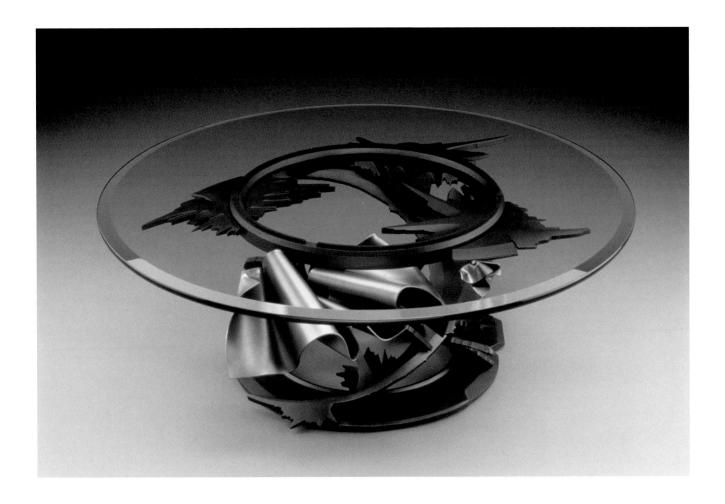

Cocktail Table, 1992, forged and fabricated steel, with glass top, 46 inches diameter x 15 3/4 inches. Private Collection. (Photograph: Bruce Miller)

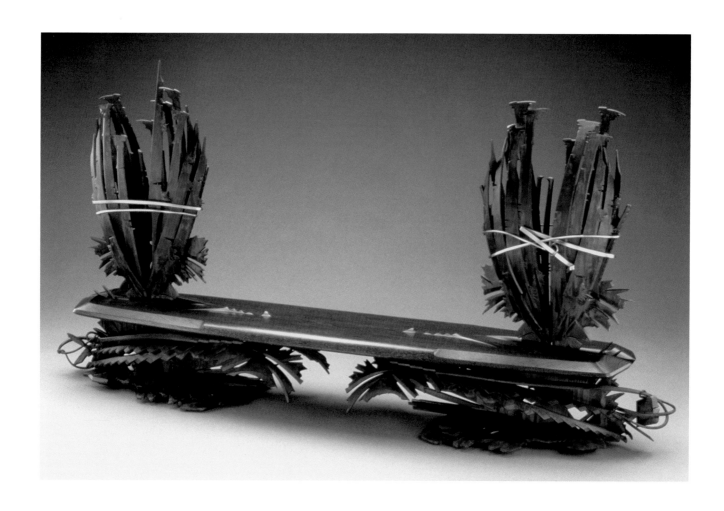

Oasis, 1994, formed and fabricated steel and stainless steel with mahogany top, 109 1/2 x 19 1/2 x 54 inches. Private Collection. (Photograph: Bruce Miller)

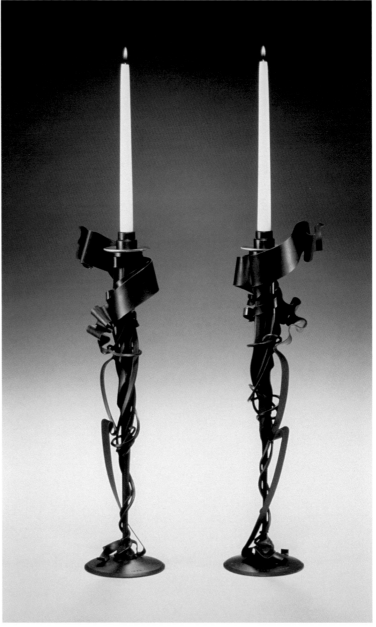

Menorah, 1999, formed and fabricated steel, brass, 20 3/4 x 5 1/4 x 9 1/2 inches. Private Collection. (Photograph: Bruce Miller)

Millennium Candleholders, 1999, formed and fabricated steel, 5 1/4 inches diameter x 17 1/2 inches. Private Collection. (Photograph: Bruce Miller)

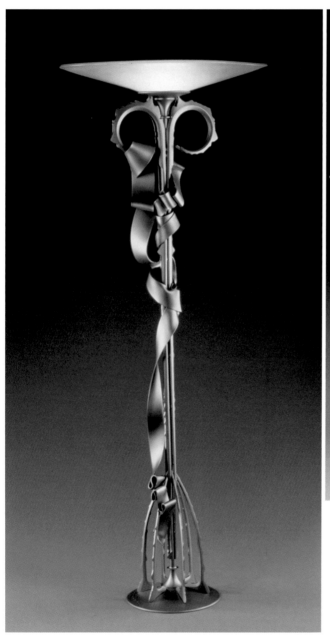

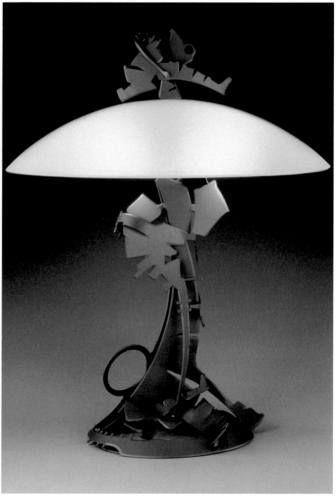

Millennium Floor Lamp, 1999, formed and fabricated stainless steel with glass shade, 29 1/2 inches diameter x 75 inches. Private Collection. (Photograph: Bruce Miller)

Dragon's Back Table Lamp, 1999, formed and fabricated steel with glass shade, 20 1/4 inches diameter x 26 1/2 inches. Private Collection. (Photograph: Bruce Miller)

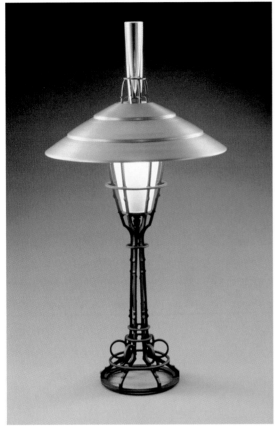

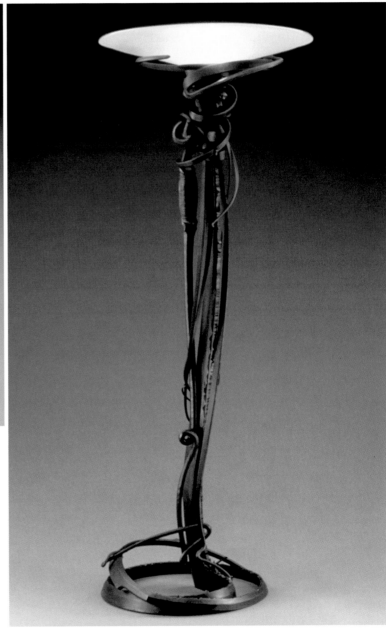

Corona Lamp, 1999, formed and fabricated steel with glass shade, 19 inches diameter x 38 inches. Private Collection. (Photograph: Bruce Miller)

Dragon's Back Floor Lamp, 1992, forged and fabricated steel, with glass shade, 36 inches diameter x 80 inches. Private Collection (Photograph: Bruce Miller)

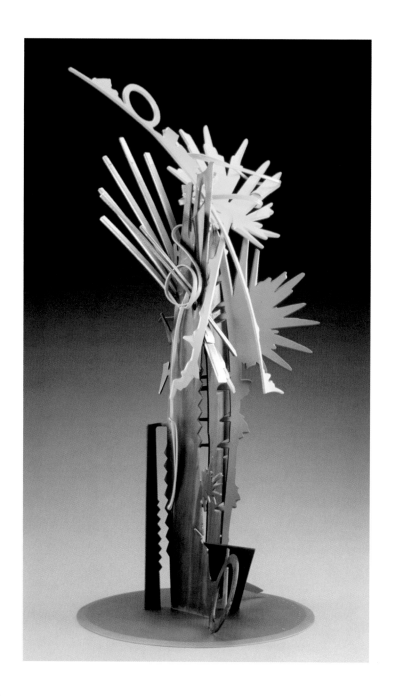

Maquette of *Traverse*, maquette of sculpture for San Diego, California, 1996, formed and fabricated steel and stainless steel (polychromed), 22 x 19 x 40 1/4 inches. (Photograph: Bruce Miller)

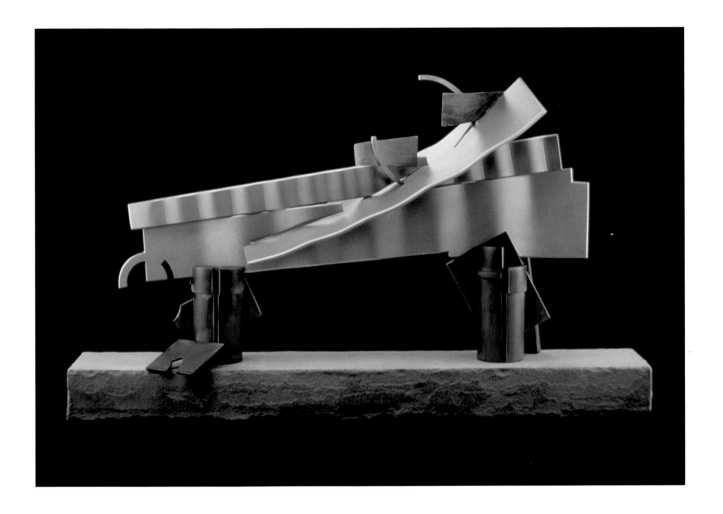

Portal, maquette of Irish Famine Memorial for Philadelphia, Pennsylvania, 1997, formed and fabricated steel, stainless steel, stone, 35 1/2 x 60 1/2 x 15 inches. (Photograph: Bruce Miller)

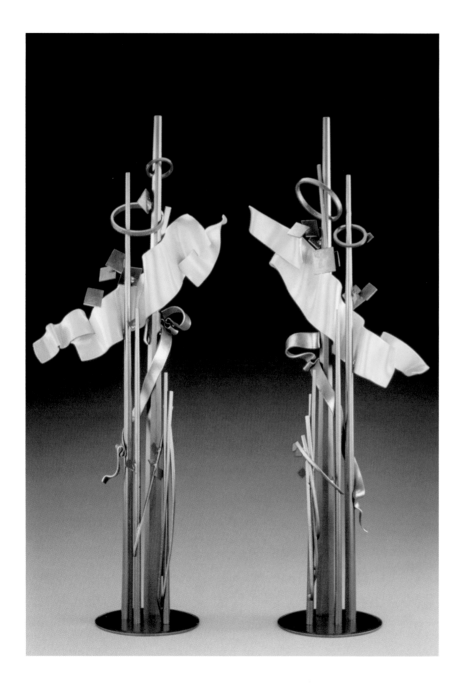

Odyssey, maquette of sculptural archway for Florida State University, Tallahassee, Florida, 1996, formed and fabricated steel, 11 1/2 x 7 x 30 inches (each). (Photograph: Bruce Miller)

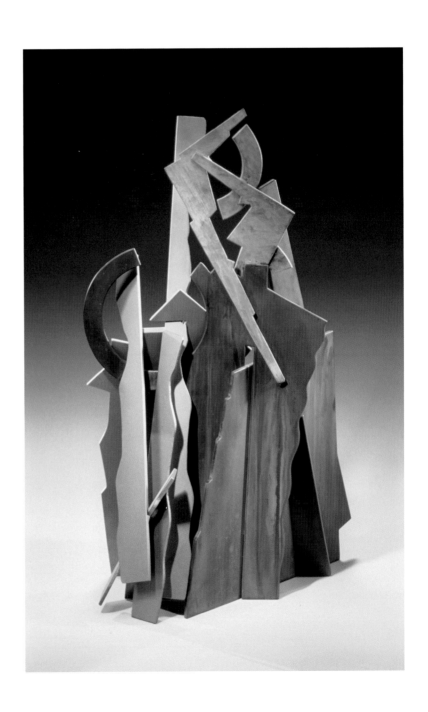

Maquette of sculpture for Eastern Connecticut State
University, 1998, 18 x 11 x 26 1/2 inches. (Photograph:
Geoff Tesch).

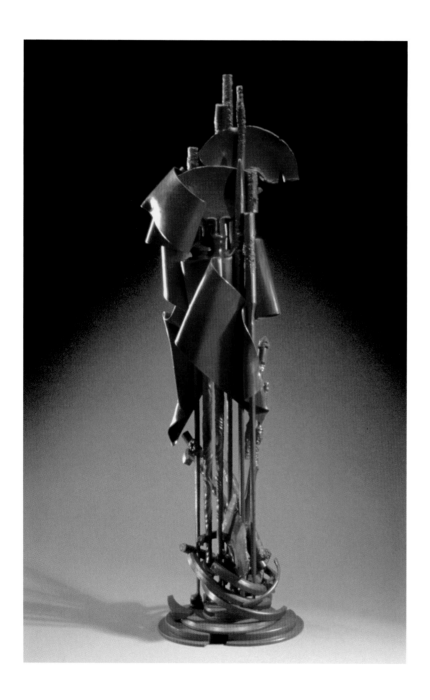

Hector, 1990, forged, fabricated, and painted steel, 31 1/4 x 23 x 104 inches. Private Collection. (Photograph: Bruce Miller)

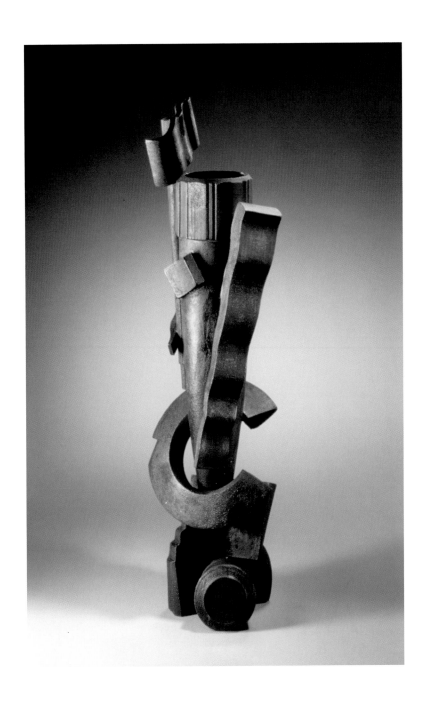

Bronze Vessel, 1999, cast bronze, 14 x 10 x 45 inches.
Private Collection. (Photograph: Geoff Tesch)

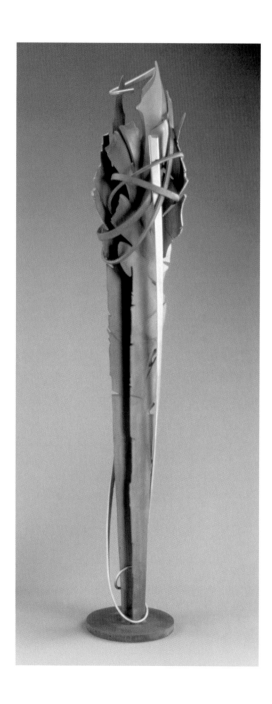

Chrysalis, 1996, formed and fabricated steel, stainless steel, 107 inches x 20 inches diameter. Private Collection.

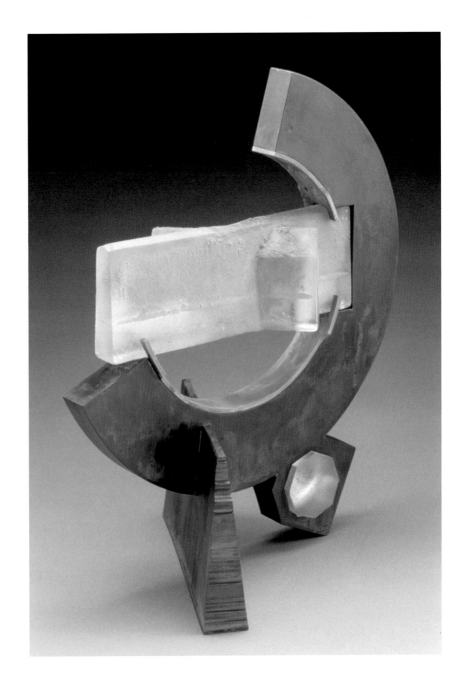

Tangent, 1999, formed and fabricated steel and copper; cast glass, 23 x 14 1/2 x 27 1/8 inches. Private Collection. (Photograph: Bruce Miller)

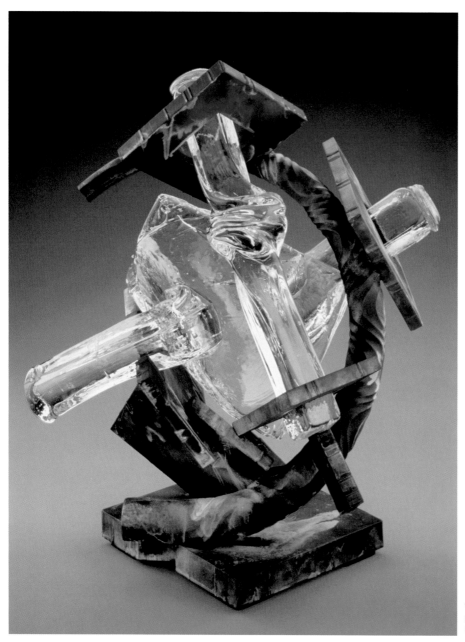

Twisted Arc, 2000, forged, twisted, and fabricated steel; clear glass, 32 x 26 x 33 1/2 inches. Private Collection. (Photograph: Bruce Miller)

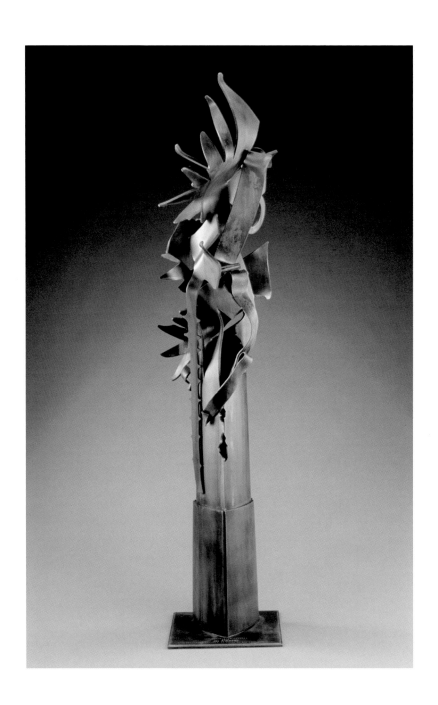

JD *Award Sculpture*, 2001, formed and fabricated steel, 23 inches diameter x 86 inches. The Commission Project, Rochester, New York. (Photograph: Bruce Miller)

Loans arranged through the kind intercession of Paley Studios

VESSELS

Vessel, 1964, raised, forged and spun silver, 36 inches. Private Collection.

Bud Vase, 1968, seamed and raised sterling silver, with moonstone, height 17 1/2 inches. Private Collection.

Chalice, 1969, forged, fabricated, and oxidized sterling silver with gold gilt and synthetic tourmalines, 5 inches diameter x 12 inches. Private Collection.

Chalice, 1976, wood model for the spun and fabricated copper and silver work, 6 inches diameter x 15 1/8 inches. Collection of Archdiocese of Philadelphia.

JEWELRY

Penannular Brooch, 1969, forged, fabricated, and oxidized bronze, with silver, gold, rutilated quartz, gold inlay, and garnet, 3 7/8 x 2 7/8 x 5 7/8 inches. Private Collection.

Sectional Brooch, 1969, silver, gold, moonstones, pearls, 3 1/2 x 1 1/4 x 8 1/2 inches. Private Collection.

Brooch, 1971, silver, gold, moonstone, pearls, glass, 5 x 3 x 6 1/2 inches. Private Collection.

Pendant, 1972, copper, gold, glass, Delrin, 5 1/2 x 3 x 16 inches. Private Collection.

Pendant, 1973, forged, fabricated, and formed silver, copper and gold, with antique cameo, pearls, and Delrin, 4 1/2 x 4 1/2 x 17 inches. Private Collection.

Pendant, 1973, forged and fabricated silver, gold, and copper, with Delrin, glass, and opal, 7 1/2 x 2 5/8 x 21 inches. Private Collection.

Pendant, 1974, fabricated silver and copper, with Delrin, 16 1/2 x 1 1/2 x 19 1/4 inches. Private Collection.

GATES AND SCREENS

Rectilinear Gate, 1976, forged, fabricated, punched, and banded steel, 35 x 5 1/2 x 90 inches. Private Collection.

Victoria and Albert Gate, 1982, forged and fabricated steel, 106 1/2 x 13 1/2 x 82 1/2 inches. Private Collection.

Architectural Screen, 1983, forged, twisted, punched, wrapped, and riveted steel and brass, 243 x 90 x 24 inches. Private Collection.

Gate Section from proposal for the Central Park Zoo, New York, 1987, forged and fabricated Cor-ten steel, with gold leaf,

75 x 66 x 166 inches. Private Collection.

Florida State University Center Gates, formed and fabricated steel, stainless steel, and bronze, 423 x 7 x 150 inches. Collection: Florida State University, State of Florida, installed April 29, 1999.

ARCHITECTURAL APPOINTMENTS

Window Grille, 1982, forged and fabricated steel, 24 x 1 1/2 x 36 inches. Collection of Dr. Metzger.

Door Handles, 1985, cast bronze, 19 x 3 x 24 inches, The Willard Building, Washington, D.C.

Facade Door Handles, 1987, cast bronze, 36 x 4 x 28 inches, Wortham Center for the Performing Arts, Houston, Texas.

Opera Box Handle, 1987, cast bronze, 3 x 4 x 19 inches, Wortham Center for the Performing Arts, Houston, Texas. Collection of Dr. Metzger.

FUNCTIONAL WORKS

Fire Grate, 1983, forged and fabricated steel, 36 x 24 x 28 inches. Private Collection.

Large Plant Stand, 1984, forged and fabricated steel, with limestone top, 55 1/2 x 26 inches diameter. Private Collection.

Lectern, 1986, forged and fabricated steel and brass, 24 x 18 x 48 inches. Private Collection.

Plant Stand, 1990, forged and fabricated steel, with slate top, 23 x 17 x 58 inches. Private Collection.

Andirons, 1992, formed and fabricated steel, 18 x 12 1/2 x 15 inches each. Private Collection.

Cocktail Table, 1992, forged and fabricated steel, with glass top, 46 inches diameter x 15 3/4 inches. Private Collection.

Splayed Bench, 1992, forged and fabricated steel, with mahogany seat, 126 x 35 x 70 inches. Private Collection.

Presentation Table #2, 1993, forged and fabricated steel, with carved slate top. 34 1/2 x 27 1/2 x 49 inches. Private Collection.

Oasis, 1994, formed and fabricated steel and stainless steel with mahogany top, 109 1/2 x 19 1/2 x 54 inches. Private Collection.

Dragon's Back Table, 1998, formed and fabricated steel, stainless steel with glass top, 69 inches diameter x 31 inches. Private Collection.

Rectilinear Table, 1997, formed and fabricated steel, stainless steel with glass top, 66 x 29 x 16 3/4 inches. Private Collection.

Sideboard with Marble, 1998, steel, stainless steel, copper, marble, 46 1/2 x 86 1/2 x 25 inches. Private Collection.

Shared Vision, 1999, formed and fabricated steel, mahogany, 105 x 32 x 39 1/2 inches. Private Collection.

Slate Top Table, 1999, formed and fabricated steel, stainless steel, and slate, 51 x 40 x 64 inches. Private Collection.

CANDLEHOLDERS

White House Candleholders, 1992, forged and fabricated steel, 6 1/2 inches diameter x 25 inches. Represented in the White House Collection of American Crafts, Museum of American Art, The Smithsonian, Washington, D.C.

Gingko Candleholders, 1994, forged and fabricated steel and brass, 6 1/4 inches diameter x 14 1/4. Private Collection.

Millennium Candleholders, 1999, formed and fabricated steel, 5 1/4 inches diameter x 17 1/2 inches. Private Collection.

Menorah, 1999, formed and fabricated steel, brass, 20 3/4 x 5 1/4 x 9 1/2 inches. Private Collection.

LAMPS

Dragon's Back Floor Lamp, 1992, forged and fabricated steel, with glass shade, 36 inches diameter x 80 inches. Private Collection.

Dragon's Back Table Lamp, 1999, formed and fabricated steel with glass shade, 20 1/4 inches diameter x 26 1/2 inches. Private Collection.

Corona Lamp, 1999, formed and fabricated steel with glass shade, 19 inches diameter x 38 inches. Private Collection.

Trellis Lamp, 1999, formed and fabricated steel with glass shade, 9 1/2 inches diameter x 45 inches. Private Collection.

Millennium Floor Lamp, 1999, formed and fabricated stainless steel with glass shade, 29 1/2 inches diameter x 75 inches. Private Collection.

MAQUETTES AND PROPOSALS

Maquette of *Pennsylvania Avenue Model of Bench and Tree Grate*, 1979, forged and fabricated steel and brass, 32 x 26 1/2 x 26 1/2 inches.

Tree Grate, 1981, cast iron, 88 inches diameter, Pennsylvania Avenue Development Corporation, Washington, D.C.

Aurora, maquette of sculpture for Charlotte Coliseum, North Carolina, 1989, forged and fabricated steel, natural patina, 27 x 24 x 53 inches. Collection of Dr. Metzger.

Maquette of a *Plaza Sculpture* for Copley Square, Boston, Massachusetts, 1990, formed, fabricated, and copper-plate steel, 15 x 13 1/2 x 27 3/4 inches.

Maquette of Sculpture for Scottsdale, Arizona, 1992, formed and fabricated steel, 8 x 8 x 19 inches.

Maquette for Reading Terminal Convention Center, Philadelphia, Pennsylvania, 1992, formed and fabricated steel, 66 1/2 x 37 1/2 x 25 inches.

Maquette of a sculptural *Archway* for Orlando, Florida, 1993, formed and fabricated steel (polychromed), 21 1/2 x 7 1/2 x 51 inches.

Mirage, maquette of sculpture for Bausch and Lomb Corporate Headquarters, Rochester, New York, 1994, formed and fabricated stainless steel, 16 x 13 x 48 3/4 inches.

Genesee Passage, maquette of sculpture for Bausch and Lomb Corporate Headquarters, Rochester, New York, 1994, formed, fabricated, and painted foam core, wood and steel, 66 x 44 x 50 inches.

Passage, maquette of sculpture for Federal Building, Asheville, North Carolina, 1994, formed and fabricated weathering steel and stainless steel, 16 1/2 x 16 1/2 x 31 1/2 inches.

Genesis, maquette of sculpture for Addison, Texas, 1996, formed and fabricated steel, stainless steel, and aluminum, 57 inches diameter x 44 inches. Collection of Betsy and Tom Kubiak.

Maquette of *Traverse*, maquette of sculpture for San Diego, California, 1996, formed and fabricated steel and stainless steel (polychromed), 22 x 19 x 40 1/4 inches.

Odyssey, maquette of sculptural archway for Florida State University, Tallahassee, Florida, 1996, formed and fabricated steel, 11 1/2 x 7 x 30 inches (each).

Portal, maquette of Irish Famine Memorial for Philadelphia, Pennsylvania, 1997, formed and fabricated steel, stainless steel, stone, 35 1/2 x 60 1/2 x 15 inches.

Cross Current, maquette of sculpture for Atlantic City, New Jersey, 1997, formed and fabricated steel, stainless steel (polychromed), 18 1/2 inches diameter x 30 inches.

Desert Willow, maquette of sculpture for Palm Desert, California, 1998, formed and fabricated steel, stainless steel, and brass, 26 1/4 inches x 11 1/2 x 21 1/4 inches.

Maquette of sculpture for Eastern Connecticut State University, 1998, 18 x 11 x 26 1/2 inches.

Maquette of sculpture for Hamilton, Ohio, 1998, formed and fabricated steel (polychromed), 16 inches diameter x 31 inches.

DRAWINGS AND GRAPHICS

Tree Study, 1963, pen and ink with watercolor wash on paper, 13 1/2 x 22 inches. Private Collection.

Stylized Tree, 1964, pen and ink on paper, 13 1/2 x 22 inches. Private Collection.

Figures in the Landscape, 1964, graphite on paper, 11 x 17 inches. Private Collection.

Proposal for a Tree Grate for Pennsylvania Avenue Development Corporation, Washington, D.C., 1979, graphite on paper, 31 1/2 x 24 inches. Collection of Katrina and Carlos Mercado.

Sculpture Proposal for the State Capitol, Harrisburg, Pennsylvania, 1982, graphite on paper, 22 x 19 inches.

Proposal for the Central Park Zoo Gate, 1983, graphite on paper, 30 x 40 inches. Collection of Mike Cardillo.

Proposal for a Sculpture for the Willard Office Building, Washington, D.C., 1985, graphite on paper, 29 x 23 inches. Collection of Mr. John and Dr. Nancy Weyl.

Reinterpretation of the Portal Gates for the 20th Anniversary of the Renwick Gallery, Smithsonian Institution, Washington, D.C., 1992, graphite on paper, 48 x 35 1/2 inches. Collection of Mr. John and Dr. Nancy Weyl.

Proposal for a Bench Commissioned by the Victoria & Albert Museum, 1994, graphite on paper, 19 x 24 inches.

Florida State University Center Gates: Proposal, 1997, red pencil on paper, 36 x 54 inches; Figurative Proposal, 1997, red pencil on paper, 36 x 57 inches; Final Design, 1997, red pencil on paper, 32 x 50 inches.

Gates Commissioned for a Private Florida Residence, 1998, graphite and red pencil on paper, 23 x 29 inches.

Monoprints from the *San Jose Series*, 1999: no. 1, 29 x 41 inches; nos. 4 and 12, 41 x 29 inches. Lithograph from the *San Jose Series*, 1999: no. 19, 41 x 29 inches. Private Collection.

Monoprints numbered 6, 24, 31 from the *Pilchuck Series*, 2000, 30 x 22 inches. Private Collection.

Gates Commissioned for a Private New York Residence, 2000, graphite and red pencil on paper, 20 x 28 inches.

Proposal for the Martin Luther King Library, Washington, D.C., 2001, red pencil on paper, 21 x 29 inches.

Proposal for an Interior Sculpture, Toronto, Canada, 2001, red pencil on paper, 23 x 29 inches.

SCULPTURE

Head, 1964, plaster, 7 x 9 x 17 inches. Collection of Jane Alexander.

Wood Carving, 1965, apple wood, 39 inches x 44 inches circumference. Private Collection.

Stone Carving, 1965, marble, 17 inches x 28 inches circumference. Private Collection.

Sculpture III, 1989, forged and fabricated steel, copper plated, 20 x 16 x 74 inches. Private Collection.

Hector, 1990, forged, fabricated, and painted steel, 31 1/4 x 23 x 104 inches. Private Collection.

Chrysalis, 1996, formed and fabricated steel, stainless steel, 107 x 20 inches diameter. Private Collection.

Bronze Vessel, 1999, cast bronze, 14 x 10 x 45 inches. Private Collection.

Tangent, 1999, formed and fabricated steel and copper; cast glass, 23 x 14 1/2 x 27 1/8 inches. Private Collection.

Twisted Arc, 2000, forged, twisted, and fabricated steel; clear glass, 32 x 26 x 33 1/2 inches. Private Collection.

JD Award Sculpture, 2001, formed and fabricated steel, 23 inches diameter x 86 inches. The Commission Project, Rochester, New York.

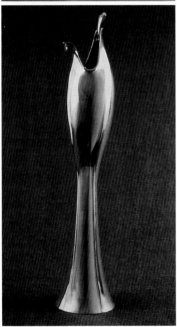

Vessel, 1964, raised, forged and spun silver, 36 inches. Private Collection. (Photograph: Bruce Miller)
Bud Vase, 1968, seamed and raised sterling silver, with moonstone, height 17 1/2 inches. Private Collection.

CHRONOLOGY

1944

Born Albert Raymond Paley, Jr., on 28 March, in Philadelphia, Pennsylvania. Parents Dorothy Appelgren (Swedish descent) and Albert Raymond Paley (Irish-English descent). First of three children (sisters Deborah Lynne, b. 1948, and Denise Anne, b. 1955).

1961

Graduates from high school.

1962

Enters Tyler School of Art, Temple University, Philadelphia.

Builds 3,000 sq. ft. sculpture studio in Pennsauken, New Jersey.

1963

Joins American Craftsmen's Council (now American Crafts Council).

1965

American Jewelry Today, Scranton, Pennsylvania, Honorable Mention.

Camden County Art Exhibit, Pennsauken, New Jersey.

1966

Receives Bachelor of Fine Arts from Tyler School of Art.

Marries Jane Alexander.

Establishes goldsmithing studio in residence in Philadelphia; formally establishes studio business under the name Albert Paley.

Contemporary Crafts for Christmas, Wilmington Society of Fine Arts, Wilmington, Delaware.

Craftsmen '66, Wilmington Society of Fine Arts, Wilmington, Delaware, National Merit Award.

Craftsmen USA. Museum of Contemporary Crafts, New York, New York, Merit Award.

1967

Receives Graduate Teaching Assistantship in sculpture and jewelry, Tyler School of Art.

American Jewelry Today, Scranton, Pennsylvania, First Prize.

Craftsmen '67, Philadelphia Civic Center, Philadelphia, Pennsylvania.

Design '67: Crafts and Graphics, Cheltenham Art Center, Cheltenham, Pennsylvania.

11th Annual Fall River Craft Show, Fall River, Massachusetts, Honorable Mention.

Newark Crafts Show, Newark Museum, Newark, New Jersey.

Philadelphia Crafts, Moore College of Art, Philadelphia, Pennsylvania.

Sterling Silver Competition, Sterling Silver Guild, New York, New York, Honorable Mention.

1968

Joins faculty of Tyler School of Art/Evening Division as Instructor to teach metalsmithing.

American Institute of Architects Exhibition. American Institute of Architects, Philadelphia, Pennsylvania.

Philadelphia Council of Professional Craftsmen Exhibition, Philadelphia Art Alliance, Philadelphia, Pennsylvania.

12th Annual Fall River Craft Show, Fall River, Massachusetts, First Prize, Honorable Mention.

Tyler Alumni Show, Tyler School of Art, Philadelphia, Pennsylvania.

Publication

Untrauch, Oppi. *Metal Techniques for Craftsmen*. Garden City, New York: Doubleday, 1968.

1969

Receives Master of Fine Arts, major in goldsmithing, Tyler School of Art.

Becomes Assistant Professor of Metals at the School for American Craftsmen, College of Fine and Applied Art, Rochester Institute of Technology, Rochester, New York (position held up to 1972).

Invitational Jewelry Exhibition, Lawrence University, Appleton, Wisconsin.

Solo Exhibition, Philadelphia Art Alliance, Philadelphia, Pennsylvania.

Solo Exhibition, Shop I, Rochester, New York.

Publication

Paley, Albert. *American Gold and Silversmiths*, introduction. Pforzheim, West Germany: Goldschmiede-Zeitung, January, 1969.

1970

Purchases home in Rochester, New York; establishes goldsmithing and ironworking studios on premises.

Lecturer, Nova Scotia College of Art and Design, Halifax, Canada.

International Jewelry Exhibition, Handwerker fur Oherhayern, Munich, West Germany.

Invitational Jewelry Show, Nan Duskin, Philadelphia, Pennsylvania.

Solo Exhibition, Nova Scotia College of Art and Design, Halifax, Nova Scotia.

Renaissance: Goldsmiths '70, St. Paul Art Center, St. Paul, Minnesota.

Second National Invitational Craft Show, Northern Illinois University, DeKalb, Illinois.

Tendencies - 1970, Schmuckmuseum und Reuchlinhaus, Pforzheim, West Germany.

Publication

Morton, Philip G. *Contemporary Jewelry: A Studio Handbook*. New York: Holt, Reinhart, and Winston, 1970.

1971

Arts and Crafts Exhibition, Mississippi Arts Festival, Jackson, Mississippi; Merit Award.

Fiber, Clay, and Metal, State University of New York College at Oneonta, Oneonta, New York.

Finger Lakes Exhibition, Memorial Art Gallery, University of Rochester, Rochester, New York. Merit Award and Jurors' Award.

First National Iron, Shop I, Rochester, New York.

Goldsmiths '70, Museum of Contemporary Crafts, New York, New York.

Inter D-2, Interamerican Craft Alliance, McAllen International Museum, McAllen, Texas.

International Jewelry Exhibition, Handwerker fur Oherhayer, Munich, West Germany.

Invitational Crafts Exhibition, Memorial Art Gallery, University of Rochester, Rochester, New York.

Invitational Craft Show, Stout State University, Menomonie, Wisconsin.

Invitational Metal and Fiber Exhibition, University Art Gallery, University of Massachusetts at Amherst.

Jewelry '71, Art Gallery of Ontario, Toronto, Canada.

Solo Exhibition, New Directions Gallery, University of Illinois, Normal, Illinois.

Projection '71, 68 tons Gallery, Alexandria, Virginia.

Second Invitational Crafts Show, Skidmore College, Saratoga Springs, New York.

Southern Tier Arts and Crafts Show, The Coming Museum of Glass, Corning, New York, Jurors' Award.

Tyler Directions '71, Tyler School of Art, Temple University, Alumni Association, The Philadelphia Civic Center, Philadelphia, Pennsylvania.

Publication

Willcox, Donald J. *Body Jewelry: International Perspectives*, Chicago, 1971.

1972

Leases industrial space for iron studio, 1237 East Main Street, Rochester, New York; hires first employee.

Associate Professor at State University of New York College at Brockport, Brockport, New York.

Lecturer, State University of New York College at Geneseo, Geneseo, New York.

American Crafts Council Northeast Exhibition, Museum of Contemporary Crafts, New York, New York.

Crafts Festival, Kenan Center, Lockport, New York.

Collectibles, Philadelphia Museum of Art, Philadelphia, Pennsylvania.

Gourmet Exhibition, Shop I., Rochester, New York.

Invitational Exhibition, Illinois State University, Normal, Illinois.

Inaugural Exhibition, Ten Arrow Gallery, Cambridge, Massachusetts.

International Jewelry Exhibition, Handwerker fur Oherhayem, Munich, West Germany.

The Intricate Object, California State College, Long Beach, California.

Invitational Crafts Exhibition, State University of New York at Albany, Albany, New York.

Invitational Jewelry Exhibition, Zlatarna Celje, Celje, Yugoslavia.

Jurors' Exhibition, Denver Designer Craftsmen, The Denver Art Museum, Denver, Colorado.

Invitational Exhibition, Memorial Art Gallery, University of Rochester, New York.

Metal '72, State University of New York College at Brockport, Brockport, New York.

Invitational Exhibition, Museum of Contemporary Crafts, New York, New York.

National Jewelry and Holloware Invitational, University of Illinois, DeKalb, Illinois.

Rochester Finger Lakes Exhibition, Memorial Art Gallery of the University of Rochester, New York.

Solo Exhibition, Earlham College, Richmond, Indiana.

Objects for Preparing Food, Museum of Contemporary Crafts, New York, New York.

Profile '72, Tyler School of Art Alumni Association, Philadelphia, Pennsylvania.

Radial 80, Xerox Square Exhibition Center, Rochester, New York.

Publication

Hughes, Graham. *The Art of Jewelry: A Survey of Craft and Creation*. London, 1972.

1973

Travels to Spain and Portugal.

International Jewelry Exhibition, Handwerker fur Oherhayern, Munich, West Germany.

Invitational Crafts Exhibition, University of New Mexico, Albuquerque, New Mexico.

Solo Exhibition, Tyler School of Art, Temple University, Philadelphia, Pennsylvania.

Paley/Castle, Herbert F. Johnson Museum of Art, Cornell University, Ithaca, New York.

Invitational Exhibition, The Renwick Gallery, Smithsonian Institution, Washington, D.C.

Smithing '73, State University of New York College at Brockport, Brockport, New York.

Up the '70s, Rohm and Haas, Philadelphia, Pennsylvania.

1974

Associate Professor with tenure, State University

Head, 1964, plaster, 7 x 9 x 17 inches. Collection of Jane Alexander.
Wood Carving, 1965, apple wood, 39 inches x 44 inches circumference. Private Collection.
Stone Carving, 1965, marble, 17 inches x 28 inches circumference. Private Collection.

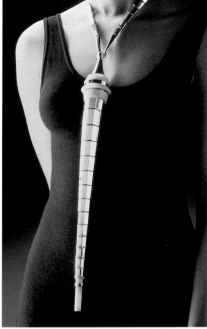

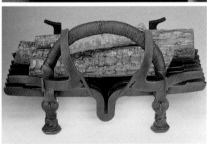

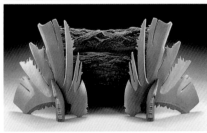

Pendant, 1974, fabricated silver and copper, with Delrin, 16 1/2 x 1 1/2 x 19 1/4 inches. Private Collection. (Photograph: Bruce Miller)

Fire Grate, 1983, forged and fabricated steel, 36 x 24 x 28 inches. Private Collection. (Photograph: Bruce Miller)

Andirons, 1992, formed and fabricated steel, 18 x 12 1/2 x 15 inches each. Private Collection. (Photograph: Bruce Miller)

of New York College at Brockport, Brockport, New York.

Marriage to Jane Alexander ends in divorce.

Meets Frances Welles.

Baroque '74, Museum of Contemporary Crafts, New York, New York.

Invitational Exhibition, Carburum Museum, Niagara Falls, New York.

Collectors, Museum of Contemporary Crafts, New York, New York, Cooper-Hewitt Museum of Decorative Arts and Design, Smithsonian Institution, New York, New York.

Embody Art, Helen Drutt Gallery, Philadelphia, Pennsylvania.

Form '74, Northern Illinois University, DeKalb, Illinois.

Goldsmith '74, Renwick Gallery, Smithsonian Institution, Washington D.C., and the Minnesota Museum of Art, St. Paul, Minnesota, Purchase Award.

Invitational Exhibition, Iowa State University, Ames, Iowa.

Solo Exhibition, California State University, Long Beach University, Long Beach, California.

Solo Exhibition, Cornell University, Ithaca, New York.

Solo Exhibition, Fairtree Gallery, New York, New York.

Solo Exhibition, Peterson Gallery, Nantucket, Massachusetts.

Touch of Gold, Philadelphia Museum of Art, Philadelphia, Pennsylvania.

Publication

Hollander, Harry. *Plastics for Jewelry*. New York: Watson-Guptill, 1974.

1975

Receives the Master Apprenticeship Grant, National Endowment for the Arts, and the Lillian Fairchild Award, University of Rochester, Rochester, New York.

Receives Design in Steel Award, American Iron and Steel Institute of America.

Blacksmith, Stuhr Museum, Grand Island, Nebraska.

Forms in Metal/ 275 Years of Metalsmithing in America, Finch College Museum of Art and The Museum of Contemporary Crafts, New York, New York.

Fourth Invitational Contemporary Crafts Exhibition, Skidmore College, Saratoga Springs, New York.

Goldsmithing Exhibition, Universidad Nacional Autonoma de Mexico, Mexico City, Mexico.

A History of Silver and Goldsmithing in America, Lowe Art Museum, University of Miami, Coral Gables, Florida.

Invitational Exhibition, Hunter Museum of Art, Chattanooga, Tennessee.

Invitational Exhibition, Iowa State University, Ames, Iowa.

Invitational Exhibition, Nina Freudenheim Gallery, Buffalo, New York.

Invitational Jewelry Exhibition, Pensacola Junior College, Pensacola, Florida.

Ironworks, Craft Center, Worcester, Massachusetts.

Metal Invitational 1975, State University College at New Paltz, New Paltz, New York.

Metals Exhibit, Humboldt State University, Arcata, California.

National Invitational Jewelry and Metalsmith, University of North Carolina, Charlotte, North Carolina.

Jewelry International: Symbolism and Imagery, Central Washington State College, Ellensburg, Washington.

Solo Exhibition, State University of New York College at Oneonta, Oneonta, New York.

25th Anniversary Exhibition, School of American Craftsmen, Rochester Institute of Technology, Rochester, New York.

The Craftsmen in America. Washington, D.C.: Ed. National Geographic Society, 1975.

Publication

DiPasquale, Dominic, and Jean Delius. *Jewelry Making: An Illustrated Guide to Technique*. Englewood Cliffs, New Jersey: Prentice-Hall, 1975.

1976

Receives the Craftsmen Fellowship Grant and the Master Apprenticeship Grant from the Endowment for the Arts.

American Crafts '76, An Aesthetic View, Museum of Contemporary Art, Chicago, Illinois.

The Blacksmith as Artist and Craftsman in the United States, Southern Illinois University, Carbondale, Illinois.

Contemporary Jewelry, Georgia State University, Atlanta, Georgia.

Invitational Exhibition, State University of New York at Fredonia, Fredonia, New York.

Invitational Exhibition, University of Nebraska, Lincoln, Nebraska.

Invitational Jewelry Exhibition, Zlatarna Celje, Celje, Yugoslavia. Design Award.

Jewelers USA, California State University, Fullerton, California.

Liturgical Art Exhibition, Philadelphia Civic Center, Philadelphia, Pennsylvania.

Metal Invitational, Montana State University, Bozeman, Montana.

National Invitational Crafts Exhibition 1976, University of Illinois, Urbana-Champaign, Illinois.

Solo Exhibition, Cooper Gallery, Newport, Rhode Island.

Solo Exhibition, Cornell University, Ithaca, New York.

Solo Exhibition, Helen Drutt Gallery, Philadelphia, Pennsylvania.

2nd Annual Jewelry Invitational, Central Washington

State College, Ellensburg, Washington.

Tokyo Triennial International Jewelry Art Exhibition, Nihon Keizai Shimbun, Seibu Museum of Art, Tokyo, Japan.

Film, *Behind the Fence: Albert Paley, Metalworker*. Produced by David Darby. Viewed — National Public Broadcasting (30 min., color, sound). Award, 2nd International Crafts Film Festival, New York State Council of the Arts, New York, New York.

Publications

Chamberlain, Marcia. *Metal Jewelry Techniques*. New York: Watson-Guptill, 1976.

Hirsh, Richard. *Raku*. 1976.

Turner, Ralph. *Contemporary Jewelry: A Critical Assessment 1945-1975*. London, 1976.

1977

American Crafts 1977, Philadelphia Museum of Art, Philadelphia, Pennsylvania.

The American Table, Fendrick Gallery, Washington D.C.

Ceremonial Objects, Florence Duhl Gallery, New York, New York.

Contemporary Works by Master Craftsmen, Museum of Fine Arts, Boston, Massachusetts.

Invitational Exhibition, Cranbrook Academy of Art, Bloomfield Hills, Michigan.

Focus on Crafts, University of Minnesota, Minneapolis, Minnesota.

Invitational Exhibition, Northern Arizona Museum, Flagstaff, Arizona.

Invitational Exhibition, University of Michigan, Ann Arbor, Michigan.

Solo Exhibition, Helen Drutt Gallery, Philadelphia, Pennsylvania.

Solo Exhibition, Theo Portmoy Gallery, New York, New York.

Pure Gold, Bodycraft Galleries, Winston-Salem, North Carolina.

Recent Works in Metal by Albert Paley, Renwick Gallery, Smithsonian Institution, Washington, D.C.

Solid Wrought, USA, Museum of Contemporary Crafts, New York, New York.

Publication

Meilach, Dona Z. *Decorative and Sculptural Ironwork*. New York: Crown, 1977.

1978

Full Professorship, State University of New York College at Brockport, Brockport, New York.

American Jewelry, Mikimoto Pearl Company, Tokyo, Japan.

Craft, Art, and Religion, Smithsonian Institution, Washington D.C. and the Vatican Museum and Galleries, Rome, Italy.

Metal Invitational, State University of New York College at Brockport, Brockport, New York.

National Metalsmith Invitational, Creative Arts Workshop, New Haven, Connecticut.

Metals Invitational, Fine Arts Gallery at the State University of New York College at Oneonta, New York.

Seventh Biennial National Invitational Crafts Exhibition, Center for the Visual Arts Gallery, Illinois State University, Normal, Illinois.

SNAG: *Jewelry and Metal Objects from the Society of North American Goldsmiths*, Schmuckmuseum, Pforzheim, West Germany. *Traveling Exhibition*:

Amersfoort Museum, Amersfoot, The Netherlands.

Bellerive Museum, Zurich, Switzerland.

Genninger Museum, Rotterdam, The Netherlands.

Goldsmiths' Hall, London, UK.

Deutsches Goldschmiedehaus, Hanau, West Germany.

Kunstindustrimuseet, Oslo, Norway.

Stadtiches Museum Schwablsch Gmund, West Germany.

Provinciaal Diamantmuseum, Antwerp, Belgium.

Publication

Southworth, Susan, and Michael Southworth. *Ornamental Ironwork: An Illustrated Guide to its Design, History and Use in American Architecture*. Boston: David Godin, 1978.

1979

Receives Craftsman and Master Fellowship Grants, National Endowment for the Arts.

Arts in Iron, Fendrick Gallery, Washington, D.C.

Beaux Arts Designer Craftsmen '79, Jurors' Presentation, Columbus Museum of Art, Columbus, Ohio.

Contemporary Crafts, Following Sea Gallery, Honolulu, Hawaii.

Contemporary Crafts, Helen Drutt Gallery, Philadelphia, Pennsylvania.

Iron Works, Locust House, Philadelphia, Pennsylvania.

Metal Exhibition, University of Georgia, Athens, Georgia.

Paley/Castle/Wildenhain, Memorial Art Gallery, University of Rochester, Rochester, New York.

1980

Lecturer at Iron Conference, Hereford, UK.

Art for Use, XIII Olympic Games, Lake Placid, New York.

Central New York Sculptors, Joe and Emily Lowe Art Gallery, Syracuse, New York.

8th Biennial National Crafts Exhibition, Southern Illinois University, Carbondale, Illinois.

The Metalwork of Albert Paley (retrospective exhibition 1962-1975). *Traveling Exhibition*:

Columbus Gallery of Fine Arts, Columbus, Ohio.

Hunter Museum of Art, Chattanooga, Tennessee.

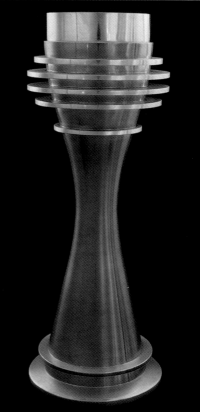

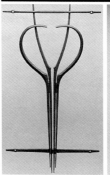 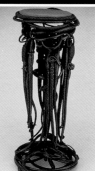

Chalice, 1976, wood model for the spun and fabricated copper and silver work, 6 inches diameter x 15 1/8 inches. Collection of Archdiocese of Philadelphia.

Window Grille, 1982, forged and fabricated steel, 24 x 1 1/2 x 36 inches. Collection of Dr. Metzger. (Photograph: Bruce Miller)

Large Plant Stand, 1984, forged and fabricated steel, with limestone top, 55 1/2 x 26 inches diameter. Private Collection. (Photograph: Bruce Miller)

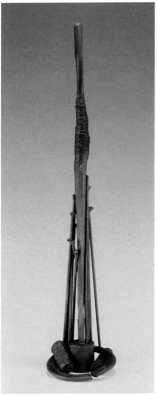

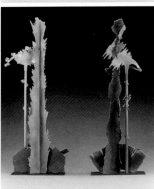

Sculpture III, 1989, forged and fabricated steel, copper plated, 20 x 16 x 74 inches. Private Collection. (Photograph: Bruce Miller)

Maquette of a sculptural *Archway* for Orlando, Florida, 1993, formed and fabricated steel (polychromed), 21 1/2 x 7 1/2 x 51 inches. (Photograph: Bruce Miller)

John Michael Kohler Arts Center, Sheboygan, Wisconsin.

Young Americans: Metal, Jurors' Presentation Exhibition, American Craft Museum, New York, New York.

1981

Art In Iron II, Fendrick Gallery, Washington D.C.

1982

Receives Award of Excellence, American Institute of Architects: Art in Architecture (*Portal Gates*, New York State Senate Chambers, Albany, New York).

Towards a New Iron Age, Victoria and Albert Museum, London, UK.

Crafts of the '80s: Fiber, Metal and Clay, The Newark Museum, Newark, New Jersey.

Video, *Handmade in America: Interview with Albert Paley*. Produced by Barbara Lee Diamondstein for ABC Video Enterprises, American Broadcasting Corporation, New York (23 min., color, sound).

Publications

Bishop, Robert and Patricia Coblents. *American Decorative Arts: 360 Years of Creative Design*. New York: Harry N. Abrams, Inc., 1982.

Jensen, Robert and Patricia Conway. *Ornamentalism*. New York: Clarkson N. Potter, Inc., 1982.

Pearson, Katharine. *American Crafts: A Source Book for the Home*. New York: Stewart, Tabori, and Chang, 1982.

Untrauch, Oppi. *Jewelry Concepts and Technologies*. Garden City, New York: Doubleday, 1982.

1983

Restores nineteenth-century carriage house for residence, with drawing and design studio.

Albert Paley, The University of Iowa Museum of Art, Iowa City, Iowa.

American Living National Treasures, Fendrick Gallery, Washington D.C.

Five Modern American Masters, The New Gallery of Contemporary American Art, Cleveland, Ohio.

The Iron Aesthetic, Fendrick Gallery, Washington, D.C.

Ornamentalism: The New Decorativeness in Architecture and Design, The Hudson River Museum, Yonkers, New York; and Archer M. Huntington Art Gallery, University of Texas, Austin.

Towards a New Iron Age, Victoria and Albert Museum, London, UK. *Traveling Exhibition:*

American Craft Museum, New York.

Flint Institute of Art, Flint, Michigan.

The Mint Museum, Charlotte, North Carolina.

National Ornamental Metal Museum, Memphis, Tennessee.

University Museum, Southern Illinois University, Carbondale, Illinois.

Video, *Hand and Eye: Decorative Arts and Fine Craftsmanship* ("Against Oblivion"). Canadian Broadcasting

Company.

Publications

Christ, Ronald and Dennis Dollens. *New York: Nomadic Design*. Barcelona, Spain: Gustavo Gilli, S. A., Distributed in US by Rizzoli International Publications, New York City, 1983, ill., p. 44.

Diamondstein, Barbaralee. *Handmade in America*. New York: Harry N. Abrams, Inc., 1983.

Park, Edward S. *Treasures of the Smithsonian*. Washington, D.C.: Smithsonian Institution, 1983.

1984

Incorporates studios as Paley Studios Ltd.

Artist-in-Residence, the Charlotte Fredericks Mowris Endowed Chair, School for American Crafts, College of Imaging Arts and Sciences, Rochester Institute of Technology, Rochester, New York (continuing).

Receives Visual Artists' Fellowship Grant, National Endowment for the Arts.

1985

Establishes second studio in renovated warehouse, 20,000 square feet, on 25 North Washington Street, Rochester, New York. Eight employees.

Albert Paley: The Art of Metal (retrospective exhibition 1972 - 1986). *Traveling Exhibition:*

Birmingham Museum of Art, Birmingham, Alabama.

Columbus Museum of Art, Columbus, Ohio.

Memorial Art Gallery, University of Rochester, Rochester, New York.

Museum of Art, Springfield, Massachusetts.

Virginia Museum of Fine Arts, Richmond, Virginia.

Publications

Campbell, Marian. *An Introduction to Ironwork*. London: Her Majesty's Stationery Office, 1985.

Dormer, Peter and Ralph Turner. *The New Jewelry: Trends and Traditions*. London: Thames and Hudson, 1985.

1986

Receives Silver Medal at the First *World Congress of Iron*, International Teaching Center of Metal Design, Aachen, West Germany.

Invitational Exhibition, Albany Institute of History and Art, Albany, New York.

Contemporary Arts: An Expanding View, organized by The Monmouth Museum, Lincroft, New Jersey, in cooperation with Helen Drutt Gallery, Philadelphia, Pennsylvania, and The Squibb Gallery, Princeton, New Jersey.

Craft Today: Poetry of the Physical, American Craft Museum, New York, New York. *Traveling Exhibition:*

The Denver Art Museum, Denver, Colorado.

Laguna Art Museum, Laguna Beach, California.

Phoenix Art Museum, Phoenix, Arizona.

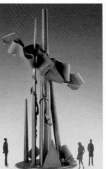
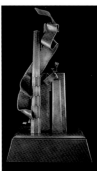

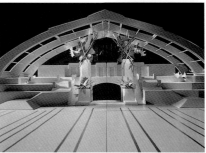

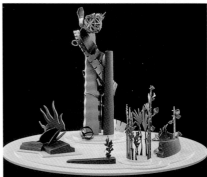

Milwaukee Art Museum, Milwaukee, Wisconsin.

The J. B. Speed Art Museum, Louisville, Kentucky.

The Virginia Museum of Fine Arts, Richmond, Virginia.

Decorative Metalworks in Architecture, University of Minnesota, Minneapolis, Minnesota.

Design in America, cultural exchange exhibition sponsored by the U.S. Information Agency, Washington, D.C., in Cankarjev Dom, Ljubljana; Muzej za Umjetnost i Orvt, Zagreb; Umetnicki Paviljon, Cvijeta Zuzoric, Belgrade, and Collegium Artisticum, Sarajevo, Yugoslavia.

Metalworks: The Art of Albert Paley, Peninsula Fine Arts Center, Newport News, Virginia.

Modern Jewelry, 1964 - 1984, The Helen Williams Drutt Collection. International Traveling Exhibition, 1986-1994: Philadelphia Art Museum, Philadelphia, Pennsylvania.

The Arkansas Arts Center, Decorative Arts Museum, Little Rock, Arkansas.

Stedelijk Museum, Amsterdam, The Netherlands.

Film, *Albert Paley: Architectural Metal Sculptor*. Produced and directed by John P. Dworakk, Virginia Museum of Fine Arts, Richmond, Virginia. Aired on Public Broadcasting System (28 min. 30 sec.).

Film, *Albert Paley: Sculpted Steel*. Produced by Anne-Marie Fendrick, commissioned by the Springfield Museum of Fine Arts, Springfield, Massachusetts (11 min.).

Video, *Decorative Metalwork in Architecture*. Videotape lectures, "Paley Studios Ltd./Survey of Historical Metalworking," and panel discussion. University of Minnesota, Minneapolis, Minnesota.

Video, *'80's Style*. Videotape panel discussions: Wendell Castle, Agnes Dennis, Edward Lucie-Smith, Albert Paley, Ettore Sottsass, Massimo Vignelli. Rochester Institute of Technology, Rochester, New York (60 min., approx.).

1987

Lecturer, *Paley Studios' Stylistic Development / Historical Survey of Architectural Ornamentation*, *Hereford-The New Tradition*, British Artist Blacksmiths Association, Hereford, UK.

The Eloquent Object, The Philbrook Museum of Art, Tulsa, Oklahoma. *Traveling Exhibition*:

The Philbrook Museum of Art, Tulsa, Oklahoma.

The Chicago Public Library Cultural Center, Chicago, Illinois.

The Oakland Museum, Oakland, California.

Museum of Fine Arts, Boston, Massachusetts.

The Orlando Museum of Art, Orlando, Florida.

Virginia Museum of Fine Arts, Richmond, Virginia.

Hereford - The New Tradition, British Artist Blacksmiths Associations, Hereford, UK.

"Paley/Castle," *'80s Style Symposium*, Rochester Institute of Technology, Rochester, New York.

The Renwick Collection, Renwick Gallery, Smithsonian Institution, Washington, D.C.

Architectural Settings: A Place for Fine Crafts, Metropolitan State College, Denver, Colorado. Keynote address.

Albert Paley's Albany Gates. Produced and directed by Bill Rowley (58 min., 16mm color/sound).

Video, *Made in America: Albert Paley and Wendell Castle*. Produced and directed by Tony Machi. Local Broadcast WXXI, Rochester, November 1987. National Broadcast, PBS, October 1988. (58 min., color/sound).

Publication

Verlag, Julius Hoffman. *Kunst aus dem Feuer* (Art from the Fire). Stuttgart: Hoffman, 1987.

1988

Marries Frances Welles.

Art in Public Space Award, DFA Ltd., National Juried Competition.

Lecturer, World Craft Council Congress, Sydney, Australia.

Albert Paley: Recent Works, Walter Gallery, Santa Monica, California.

Architectural Art: Affirming the Design Relationship, American Craft Museum, New York, New York. *Traveling Exhibition*:

Trammel-Crow Center, Dallas, Texas.

Murry Feldman Gallery, Los Angeles, California.

Pacific Design Center, Los Angeles, California.

Huntsville Museum of Art, Huntsville, Alabama.

Oklahoma City Art Museum, Oklahoma City, Oklahoma.

Masters of American Metalsmithing, organized by the National Ornamental Metal Museum, Memphis, Tennessee; exhibited at Schering-Plough Corporation, Madison, New Jersey.

Public Art: Making a Better Place to Live, Tower Fine Arts Gallery, State University of New York College at Brockport, Brockport, New York.

Publications

Brayer, Elizabeth. *MAGnum Opus*. Rochester, New York: Memorial Art Gallery of the University of Rochester, 1988.

Carlock, Marty. *A Guide to Public Art in Greater Boston*. Boston, MA: The Harvard Common Press, 1988.

Mayer, Barbara. *Contemporary American Craft Art: A Collector's Guide*. Utah: Peregrine Smith Books: 1988.

1989

Receives Honorary Doctorate of Fine Arts, University of Rochester, Rochester, New York.

Lecturer, *Albert Paley, Jewellery to Architectural Metalwork*, The Art Gallery of Western Australia.

Lecturer Demonstrator, *First International Festival of Iron*, Cardiff Conference, Cardiff, UK.

Albert Paley, Fendrick Gallery, Washington, D.C.

Albert Paley, Ironbridge Gorge Museum, Telford,

Aurora, maquette of sculpture for Charlotte Coliseum, North Carolina, 1989, forged and fabricated steel, natural patina, 27 x 24 x 53 inches. Collection of Dr. Metzger. (Photograph: Bruce Miller)

Maquette of a *Plaza Sculpture* for Copley Square, Boston, Massachusetts, 1990, formed, fabricated, and copper-plate steel, 15 x 13 1/2 x 27 3/4 inches. (Photograph: Bruce Miller)

Maquette for Reading Terminal Convention Center, Philadelphia, Pennsylvania, 1992, formed and fabricated steel, 66 1/2 x 37 1/2 x 25 inches. (Photograph: Bruce Miller).

Genesis, maquette of sculpture for Addison, Texas, 1996, formed and fabricated steel, stainless steel, and aluminum, 57 inches diameter x 44 inches. Collection of Betsy and Tom Kubiak. (Photograph: Bruce Miller)

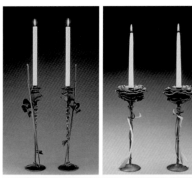

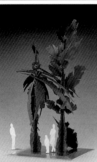

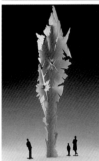

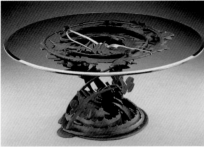

White House Candleholders, 1992, forged and fabricated steel, 6 1/2 inches diameter x 25 inches. Represented in the White House Collection of American Crafts, Museum of American Art, Smithsonian Institution, Washington, D.C. (Photograph: Bruce Miller)

Gingko Candleholders, 1994, forged and fabricated steel and brass, 6 1/4 inches diameter x 14 1/4. Private Collection. (Photograph: Bruce Miller)

Dragon's Back Table, 1998, formed and fabricated steel, stainless steel; with glass top. 69 inches diameter x 31 inches. 51 inches diameter x 30 inches. Private Collection. (Photograph: Bruce Miller)

Mirage, maquette of sculpture for Bausch and Lomb Corporate Headquarters, Rochester, New York, 1994, formed and fabricated stainless steel, 16 x 13 x 48 3/4 inches. (Photograph: Bruce Miller)

Passage, maquette of sculpture for Federal Building, Asheville, North Carolina, 1994, formed and fabricated weathering steel and stainless steel, 16 1/2 x 16 1/2 x 31 1/2 inches. (Photograph: Bruce Miller)

England; National Museum of Wales, Cardiff, Wales.

Albert Paley, Metal Sculpture, Walter Gallery, Santa Monica, California.

Artful Objects: Recent American Crafts, Fort Wayne Museum of Art, Fort Wayne, Indiana.

CRAFT TODAY USA, European touring exhibition sponsored by the US Information Agency, Washington, D.C.:

Musée des Arts Decoratifs, Paris, France.

Museum of Applied Art, Helsinki, Finland.

Museum fur Kunsthandwerk, Frankfurt, Germany.

Zacheta Gallery, Warsaw, Poland.

Musée des Arts Decoratifs, Lausanne, Switzerland.

Museum of Decorative and Applied Folk Art, Moscow, Russia.

State Painting and Sculpture Museum, Ankara, Turkey.

The Oslo Museum of Applied Art, Oslo, Norway.

St. Peter's Abbey, Ghent, Belgium.

Amerika Haus, Berlin, Germany.

The Zappeion, Athens, Greece.

Slovak National Gallery, Bratislava, Czechoslovakia.

The Grassi Museum, Leipzig, Germany.

Sala Sant Juame de la Fundacio "La Caixa," Barcelona, Spain.

The Gulbenkian, Lisbon, Portugal.

1990

Albert Paley: Recent Works, Gerald Peters Gallery, Santa Fe, New Mexico.

Albert Paley, Roanoke Museum of Fine Arts, Roanoke, Virginia.

Arts Against Aids, Washington, D.C.

Art that Works: Decorative Arts of the Eighties, Crafted in America, National Traveling Exhibition, 1990 - 1993, Art Services International.

Mint Museum of Art, Charlotte, North Carolina.

Huntsville Museum of Art, Huntsville, Alabama.

Minnesota Museum of Art, St. Paul, Minnesota.

Philbrook Museum of Art, Tulsa, Oklahoma.

Canadian Craft Museum.

DeCordora and Dana Museum, Lincoln, Massachusetts.

Dayton Art Institute, Dayton, Ohio.

Arkansas Art Center, Little Rock, Arkansas.

Hunter Museum of Art, Chattanooga, Tennessee.

Lowe Art Museum, Coral Gables, Florida.

Columbus Museum of Art, Columbus, Georgia.

Ball State University, Muncie, Indiana.

A Decade of Craft, American Craft Museum, New York, New York.

Paley, Dawson Gallery, Rochester, New York.

Sculpture '90, Fendrick Gallery, Washington, D.C.
Publications

Buff, Sheila. *Custom Made*. New York: MacMillian

Publishing Company, 1990.

Conway, Patricia. *Art for Everyday: The New Craft Movement*. New York: Clarkson Potter/Publishers, 1990.

Miller, R. Craig. *Modern Design - In the Metropolitan Museum of Art: 1890-1990*. New York: Harry N. Abrams, Inc., 1990.

Minamizawa, Hiroshi. *The World of Decorative & Architectural Wrought Iron*. Kyoto, Japan: Yoshiyo Kobo Co., Ltd., 1990.

Smithsonian Institution. *A Picture Tour of the Smithsonian*. Washington, D.C.: Smithsonian Institution Press, 1990.

Waite, Diana S. *Ornamental Ironwork*. Albany, New York: Mount Ida Press, 1990.

1991

Receives Artist's Fellowship, New York Foundation for the Arts, New York City, New York.

Lecturer and Panel Member, *Art and Architecture*, World Crafts Council, Barcelona, Spain.

Lecturer and Juror, *Second World Congress of Smiths*, Aachen, Germany.

Albert Paley: Architectural Metalwork, Hellmuth, Obata and Kassabaum, Washington, D.C.

Albert Paley: New Works in Forged Steel, Snyderman Gallery, Philadelphia, Pennsylvania.

Albert Paley: 1980-1990, Barbara Fendrick Gallery, New York, New York.

Albert Paley: Sculptural Adornment (jewelry retrospective), Renwick Gallery, Smithsonian Institution, Washington, D.C.

Albert Paley: Sculpture. University of the Arts, Philadelphia, Pennsylvania and the Naples/Marco Philharmonic Center for the Arts, Naples, Florida.

Collecting American Decorative Arts and Sculpture: 1971 - 1991, Museum of Fine Arts, Boston, Massachusetts.

Contemporary Furniture Makers of the American Northeast, The Gallery at Bristol-Myers Squibb, Princeton, New Jersey.

Furniture as Art, Art Gallery, Montgomery College, Rockville Campus, Rockville, Maryland.

Japan/USA Invitational Exhibition. Kanawazawa, Japan.

Sculpture '91, Monroe County Parks Department, Highland Park, Rochester, New York.

Albert Paley: Sculptures. Rosenwald-Wolf Gallery, Philadelphia, College of Art & Design, The University of the Arts. A video documentation of works in progress for this exhibition. (Approx. 20 min., color/sound).
Publications

Collecting American Decorative Arts and Sculptures - 1971 - 1991. Boston, Massachusetts: Museum of Fine Arts, 1991.

Creative Designs in Furniture. Madison, Wisconsin: Kraus Sikes, Inc., 1991.

International Crafts. New York: Thames and

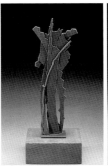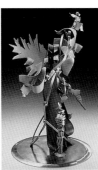

Hudson, 1991.

1992

Lecturer, *Jewellers and Metalsmiths Group of Australia,* Perth, Australia.

Lecturer, *The Art of Metal: Jewellry to Architecture,* Design Visions: The Australian International Crafts Triennial, Art Gallery of Western Australia, Perth, Australia.

Albert Paley: Baroque Modernism, Peter Joseph Gallery, New York, New York.

Albert Paley: Recent Sculpture, Samuel P. Harn Museum of Art, University of Florida, Gainesville, Florida.

Albert Paley: Recent Works, Dawson Gallery, Rochester, New York.

Albert Paley: Studies for the "Portal Gates," Renwick Gallery, Smithsonian Institution, Washington, D.C.

Design Visions, exhibition in association with The Second Australian International Crafts Triennial, Perth, Australia.

Eccentric Futures + Objects, Gensler and Associates Architects, San Francisco, California.

Patterns and Layers, Schick Art Gallery, Skidmore College, Saratoga Springs, New York.

Revolving Techniques, James A Michener Art Museum, Doylestown, Pennsylvania.

Tokyo Art Expo, exhibition of sculpture and project documentation, Tokyo, Japan.

Publications

Bach, Penny Balkin. *Public Art in Philadelphia.* Philadelphia, Pennsylvania: Temple University Press, 1992.

Barquist, David L., *American Tables and Looking Glasses.* New Haven, Connecticut: Yale University Art Gallery, 1992.

1993

Lecturer, *From Jewelry to Architectural Ornamentation,* University of Northumbria at Newcastle, Newcastle-upon-Tyne, UK.

Lecturer, *From Jewelry to Architectural Ornamentation,* Glasglow School of Art, Glasglow, UK.

Albert Paley, Reggiani Light Gallery and Peter Joseph Gallery, New York, New York.

Albert Paley: New Works, The Art Complex Museum, Duxbury, Massachusetts.

Art and Application, Turbulence, New York, New York.

The Blacksmithing Craft Continuum, National Ornamental Metal Museum, Memphis, Tennessee.

Collectors Annual Exhibition, Boca Museum, Boca Raton, Florida.

Formed by Fire, The Carnegie Museum of Art, Pittsburgh, Pennsylvania.

Furniture Fantasy, Susquehanna Art Museum, Harrisburg, Pennsylvania.

Modern Metalwork in The Metropolitan Museum of Art, Metropolitan Museum of Art, New York, New York.

Our Public Image, H. and W. Bechtler Gallery, Charlotte, North Carolina.

Sculpture by Albert Paley, San Antonio Art Institute, San Antonio, Texas.

Walking Tours of Downtown Rochester: Images of History. Rochester: The Landmark Society of Western New York. 1993.

1994

Elected Fellow, College of Fellows, American Craft Council.

Lecturer, *From Foundary and Forge: An International Ironwork Symposium,* Victoria and Albert Museum, London, UK.

Lecturer, *From Jewelry to Architectural Ornamentation,* University of Brighton, Brighton, Sussex, UK.

Lecturer and demonstrator, *Metalwork in Architecture and Public Design,* Craft and Design Centre of Helsinki, Helsinki, Finland.

Albert Paley: Drawings and Sculpture, Temple Gallery, Philadelphia, Pennsylvania.

Albert Paley: Organic Logic, Peter Joseph Gallery, Southampton, New York.

Allusion/Illusion, Florida State University Museum of Fine Arts, Florida.

Dialogues: On and Off the Wall, Peter Joseph Gallery, Schmidt Bingham Gallery and Garth Clark Gallery, New York, New York.

Faculty Exhibition Bevier Gallery, Rochester Institute of Technology, Rochester, New York.

Inspiration and Context: The Drawings of Albert Paley, Memorial Art Gallery of the University of Rochester, Rochester, New York. *Traveling Exhibition:*

City of Orlando, Florida.

The Hunter Museum of Art, Chattanooga, Tennessee.

The Delaware Art Museum, Newark, Delaware.

The Burchfield - Penney Art Center, Buffalo, New York.

Masterworks Two, Peter Joseph Gallery, New York, New York.

Metallic, Northern Michigan University, Lee High Gallery, Marquette, Michigan.

A Portrait of a Nation, Greater Reston Art Center, Reston, Virginia.

Schmuck Unserer Zeit, 1964 - 1993 (The Jewelry of our Time), Museum Bellerive, Zurich, Switzerland.

Works in Metal, The Wetsman Collection, Birmingham, Michigan.

Video, *American Craft Series: Albert Paley - Metal Smith.* NHK TV (Japanese Public Television). In Japanese (Approx. 20 min., HDTV color/sound).

Publications

Byars, Mel. *The Design Encyclopedia.* New York: John Wiley & Sons, Inc., 1994.

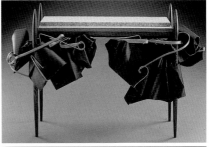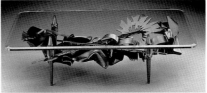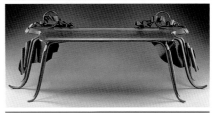

Maquette of Sculpture for Scottsdale, Arizona, 1992, formed and fabricated steel, 8 x 8 x 19 inches. (Photograph: Bruce Miller)

Cross Current, maquette of sculpture for Atlantic City, New Jersey, 1997, formed and fabricated steel, stainless steel (polychromed), 18 1/2 inches diameter x 30 inches. (Photograph: Geoff Tesch)

Sideboard with Granite, 1998, steel, stainless steel, copper, granite, 45 3/4 x 75 x 23 1/2 inches. Private Collection. (Photograph: Bruce Miller)

Rectilinear Table, 1997, formed and fabricated steel, stainless steel with glass top, 66 x 29 x 16 3/4 inches. Private Collection. (Photograph: Bruce Miller)

Shared Vision, 1999, formed and fabricated steel, mahogany, 105 x 32 x 39 1/2 inches. Private Collection. (Photograph: Bruce Miller)

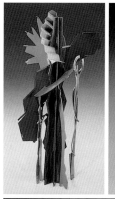
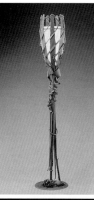
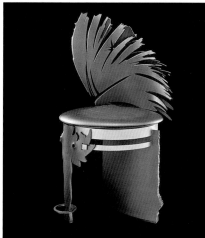
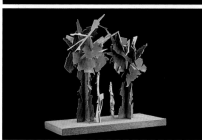

Maquette of sculpture for Hamilton, Ohio, 1998, formed and fabricated steel (polychromed), 16 inches diameter by 31 inches. (Photograph: Geoff Tesch)

Trellis Lamp, 1999, formed and fabricated steel with glass shade, 9 1/2 inches diameter x 45 inches. Private Collection. (Photograph: Bruce Miller)

Slate Top Table, 1999, formed and fabricated steel, stainless steel, and slate, 51 x 40 x 64 inches. Private Collection. (Photograph: Bruce Miller)

Desert Willow, maquette of sculpture for Palm Desert, California, 1998, formed and fabricated steel, stainless steel, and brass, 26 1/4 inches x 11 1/2 x 21 1/4 inches.

Dormer, Peter and Ralph Turner. *The New Jewelry: Trends and Traditions*. Revised edition. London: Thames and Hudson, 1994.

Jeon, Yong-il. *Techniques of Metalsmithing & Jewelry Making*. Seoul, Korea: Design House, 1994.

Lewin, Susan Grant. *One of a Kind, American Art Jewelry Today*. New York: Abrams, Inc., 1994.

Simpson, Tommy, and Lisa Hammel. *Hand and Home: The Homes of American Craftsmen*. New York: Bullfinch Press/Little, Brown and Company, 1994.

1995

Leases third studio space with 75 - foot tall interior ceiling for large-scale sculpture fabrication, to operate concurrently with other two studios. Ten employees.

Receives Citations and Fellowship Award, National Association of Schools of Art and Design (NASAD).

Receives Institute Honors. The American Institute of Architects (AIA). National Committee on Design.

Lecturer, *From Jewelry to Architectural Ornamentation*, National Museum of Contemporary Fine Arts, Seoul, Republic of South Korea.

Lecturer and demonstrator, *International Metal Arts Workshop and Seminar*, Won-Kwang University, Iri City, Republic of South Korea.

Albert Paley: Furniture, Galerie Simonne Stern, New Orleans, Louisiana.

Albert Paley: Recent Sculpture, Indigo Galleries, Boca Raton, Florida.

Albert Paley: Sculpture and Drawings, Chang Gallery, Kansas State University, Manhattan, Kansas.

Bausch & Lomb Art Commissions, The Gallery at One Bausch & Lomb Place, Rochester, New York.

Breaking Barriers: Recent American Craft, Portland Museum of Art, Portland, Oregon. *Traveling Exhibition:*

Madison Art Center, Madison, Wisconsin.

Albany Art Museum, Albany, Georgia.

American Craft Museum, New York, New York.

Eightieth Anniversary Exhibition, Philadelphia Art Alliance, Pennsylvania.

Festive Lights: Menorahs from Rochester Collections, Memorial Art Gallery, Rochester, New York.

Form, Function, Fantasy: The Craft Art Collection, Burchfield-Penney Art Center, Buffalo, New York.

Furniture Beyond Function, Sandy Carson Gallery, Denver, Colorado.

Gold and Silver Jewelry: 1995, American Craft Museum, New York, New York.

International Metal Arts Exhibition, Won-Kwang University, Iri City, Republic of South Korea.

Light Interpretations: A Hanukah Menorah Invitational, The Jewish Museum, San Francisco, California.

Masterworks, Indigo Galleries, Boca Raton, Florida.

Organic Logic, Indigo Galleries, Boca Raton, Florida.

Prague: Secret Fire, Frick Gallery, University of Pittsburgh, Pennsylvania.

Sammy Peters and Albert Paley, The Bell Gallery, Birmingham, Michigan.

The White House Collection of American Crafts, Renwick Gallery of the National Museum of American Art, Smithsonian Institution, Washington, D.C.

Memorial Art Gallery of the University of Rochester, New York.

American Craft Museum, New York, New York.

George Walter Vincent Smith Art Museum, Springfield, Massachusetts.

Los Angeles County Museum of Art, Los Angeles, California.

Publications

Chatwin, Amina. *Into the New Iron Age: Modern British Blacksmiths*. Cheltenham, England: Coach House Publishing, 1995.

Lucie-Smith, Edward. *Art Today*. London: Phaidon Press Limited, 1995.

Monroe, Michael W. *The White House Collection on American Crafts*. New York: Harry N. Abrams, Inc., 1995.

National Museum of American Art. *National Museum of American Art*. Washington, D.C.: National Museum of American Art, Smithsonian Institution, 1995.

Toledo Museum of Art. *Toledo Treasures*. New York: Hudson Hills Press, 1995.

1996

Receives Honorary Doctorate of Fine Arts, St. Lawrence University, Canton, New York.

Age of Steel: Recent Sculpture by Albert Paley, Museum of Art, Brigham Young University, Provo, Utah.

Albert Paley: Decorative Arts and Drawings, Images Gallery, Toledo, Ohio.

Albert Paley, Museum of Art, Provo, Utah.

Albert Paley, Riva Yares Gallery, Scottsdale, Arizona.

Art to Art: Albert Paley, Jim Dine, and Therman Statom, The Toledo Museum of Art, Toledo, Ohio.

International Jewelry from Europe and the USA, Crafts Council Gallery, London, UK.

North American Metal Arts Invitational Exhibition: Heritage and Diversity, Montgomery College, Rockville, Maryland.

The Seattle Art Expo, Seattle, Washington.

Publications

Lucie-Smith, Edward. *The Art of Albert Paley*. New York: Harry N. Abrams, Inc., 1996.

Turner, Ralph. *Jewelry in Europe and America: New Times, New Thinking*. London: Thames and Hudson, Ltd., 1996.

1997

Receives Honorary Doctorate of Fine Arts, State University of New York at Brockport, Brockport, New York.

Albert Paley, Bryan Ohno Gallery, Seattle, Washington.

Albert Paley, Morgan Gallery, Kansas City, Missouri.

Albert Paley: *Recent Work*, Indigo Galleries, Boca Raton, Florida.

Albert Paley: *Selected Sculpture*, Riva Yares Gallery, Scottsdale, Arizona.

Albert Paley: *Selected Works*, Fine Art Society, London, UK.

Art Expo Chicago, selected work from the Richard Gray Gallery, Chicago, Illinois.

Masters of the Medium Award, James Renwick Alliance, Renwick Gallery, Smithsonian Institute, Washington D.C.

Award of Excellence, Catalog, Salt Lake City AIGA 100, Age of Steel, American Institute of Graphic Artists, Salt Lake City Chapter.

1998

Lifetime Achievement Award, Arts and Cultural Council of Greater Rochester, Rochester, New York.

Albert Paley: A *Dialogue of Architecture, Decorative Arts and Design*, Chicago Design Show, Chicago, Illinois.

Albert Paley, Leo Kaplan Modern, New York, New York.

Albert Paley, Maurine Littleton Gallery, Washington D.C.

Publication

Dictionnaire Internationale du Bijou. Paris: Editions du Regard. 1998.

Renwick Gallery. *Skilled Work: American Craft in the Renwick Gallery*. Washington, D.C.: Renwick Gallery and Smithsonian Institution Press, 1998.

1999

Albert Paley, Leo Kaplan Modern, New York, New York.

Albert Paley: *Monotypes and small sculptures*, The Upstairs Gallery, Gallery Picture Framing, Rochester, New York.

Albert Paley: *Organic Complexity*, Gremillion and Co. Fine Art, Houston, Texas.

Albert Paley: *Steel to Glass*, Bryan Ohno Gallery, Seattle, Washington.

Congju International Craft Biennale '99, Congju City, Korea.

Video, Tony Machi, *Albert Paley: Man of Steel*. Produced and directed by Tony Machi, Machi and Machi Productions. (Approx. 57 min. color/sound) PBS National Broadcast, January 12, 2001.

Publications

Fox & Fowle: function, structure, beauty. Preface by Bruce S. Fowle; foreword by Robert F. Fox; introduction by Susan Doubilet. Milano: L'arca, 1999.

Horn, Robyn. *Living with Form: the Horn collection of contemporary craft*. Little Rock, Arkansas: Bradley Publishing in cooperation with the Arkansas Arts Center, 1999.

2000

Albert Paley: *Art in* Architecture, Gremillion Fine Art, Houston, Texas.

Albert Paley: *Integration and Dialogue*, Riley Hawk Galleries, Kirkland, Washington.

Albert Paley, Maurine Littleton Gallery, Washington, D.C.

Albert Paley, R. Duane Reed Gallery, St. Louis, Missouri.

Albert Paley: *Pilchuck Series*, Riley Hawk Galleries, Cleveland and Columbus, Ohio.

Albert Paley: *Sculpture*, Galerie Simonne Stern, New Orleans, Louisiana.

2001

Lecturer, *Architectural Sculpture*, 19th International Sculpture Conference: Pittsburgh, Pennsylvania.

Lecturer, Kranert Art Museum, University of Illinois at Champaign / Urbana, Illinois.

Monoprint from the *San Jose Series*, 1999: no. 12, 41 x 29 inches. Private collection. (Photograph: Geoff Tesch)

Monoprint from the *Pilchuck Series*, 2000: no. 31, 30 x 22 inches. Private Collection. (Photograph: Geoff Tesch)

SELECTED BIBLIOGRAPHY

Bach, Penny Balkin. *Public Art in Philadelphia*. Philadelphia, Pennsylvania: Temple University Press, 1992.

Barquist, David L. *American Tables and Looking Glasses*. New Haven, Connecticut: Yale University Art Gallery, 1992.

Bishop, Robert and Patricia Coblents. *American Decorative Arts: 360 Years of Creative Design*. New York: Harry N. Abrams, Inc., 1982.

Brayer, Elizabeth. *MAGnum Opus*. Rochester, New York: Memorial Art Gallery of the University of Rochester, 1988

Buff, Sheila. *Custom Made*. New York: MacMillan Publishing Company, 1990.

Byars, Mel. *The Design Encyclopedia*. New York: John Wiley & Sons, Inc., 1994.

Campbell, Marian. *An Introduction to Ironwork*. London: Her Majesty's Stationery Office, 1985.

Carlock, Marty. *A Guide to Public Art in Greater Boston*. Boston, Massachusetts: The Harvard Common Press, 1988.

Chamberlain, Marcia. *Metal Jewelry Techniques*. New York: Watson-Guptill, 1976.

Chatwin, Amina. *Into the New Iron Age: Modern British Blacksmiths*. Cheltenham, England: Coach House Publishing, 1995.

Christ, Ronald and Dennis Dollens. *New York: Nomadic Design*. Barcelona, Spain: Gustavo Gilli, S.A., Distributed in US by Rizzoli International Publications, New York City, 1983, ill., p. 44.

Collecting American Decorative Arts and Sculptures - 1971 - 1991. Boston, Massachusetts: Museum of Fine Arts, 1991.

Conway, Patricia. *Art for Everyday: The New Craft Movement*. New York: Clarkson Potter/Publishers, 1990.

The Craftsman in America. Washington, D.C.: Ed. National Geographic Society, 1975.

Creative Designs in Furniture. Madison, Wisconsin: Kraus Sikes, Inc., 1991.

Diamondstein, Barbaralee. *Handmade in America*. New York: Harry N. Abrams, Inc., 1983.

Dictionary of International Biography. London, 1972.

Dictionnaire International du Bijou. Paris: Editions du Regard, 1998.

DiPasquale, Dominic, and Jean Delius. *Jewelry Making: An Illustrated Guide to Technique*. Englewood Cliffs, New Jersey: Prentice-Hall, 1975.

Dormer, Peter and Ralph Turner. *The New Jewelry: Trends and Traditions*. London: Thames and Hudson, 1985.

Dormer, Peter and Ralph Turner. *The New Jewelry: Trends and Traditions*. Revised edition. London: Thames and Hudson, 1994.

Fox & Fowle: function, structure, beauty. Preface by Bruce S. Fowle; foreword by Robert F. Fox; introduction by Susan Doubilet. Milano: L'arca, 1999.

Hirsh, Richard. *Raku*. 1976.

Hollander, Harry. *Plastics for Jewelry*. New York: Watson-Guptill, 1974.

Horn, Robyn. *Living with Form: the Horn collection of contemporary craft*. Little Rock, Arkansas: Bradley Publishing in cooperation with the Arkansas Arts Center, 1999.

Hughes, Graham. *The Art of Jewelry: A Survey of Craft and Creation*. London, 1972.

International Crafts. New York: Thames and Hudson, 1991.

Jensen, Robert and Patricia Conway. *Ornamentalism*. New York: Clarkson N. Potter, Inc., 1982.

Jeon, Yong-il. *Techniques of Metalsmithing & Jewelry Making*. Seoul, Korea: Design House, 1994.

Lewin, Susan Grant. *One of a Kind, American Art Jewelry Today*. New York: Abrams, Inc., 1994.

Lucie-Smith, Edward. *The Art of Albert Paley*. New York: Harry N. Abrams, Inc., 1996

Lucie-Smith, Edward. *Art Today*. London: Phaidon Press Limited, 1995.

Mayer, Barbara. *Contemporary American Craft Art: A Collector's Guide*. Utah: Peregrine Smith Books, 1988.

Meilach, Dona Z. *Decorative and Sculptural Ironwork*. New York: Crown, 1977.

Meilach, Dona Z. *Decorative and Sculptural Ironwork*. 2nd Edition. Atglen, Pennsylvania: Schiffer Publishing, 1999.

Miller, R. Craig. *Modern Design - In the Metropolitan Museum of Art: 1890-1990*. New York: Harry N. Abrams, Inc., 1990

Minamizawa, Hiroshi. *The World of Decorative & Architectural Wrought Iron*. Kyoto, Japan: Yoshiyo Kobo Co., Ltd., 1990.

Monroe, Michael W. *The White House Collection of American Crafts*. New York: Harry N. Abrams, Inc., 1995.

Morton, Philip G. *Contemporary Jewelry: A Studio Handbook*. New York: Holt, Reinhart, and Winston, 1970.

National Museum of American Art. *National Museum of American Art*. Washington, D.C.: National Museum of American Art, Smithsonian Institution, 1995.

Paley, Albert. *American Gold and Silversmiths*, introduction. Pforzheim, West Germany: Goldschmiede-Zeitung, January, 1969.

Park, Edward S. *Treasures of the Smithsonian*. Washington, D.C.: Smithsonian Institution, 1983.

Pearson, Katharine. *American Crafts: A Source Book for the Home*. New York: Stewart, Tabori, and Chang, 1982.

Reisem, Richard O. *200 Years of Rochester Architecture and Gardens*. Rochester, New York: Landmark Society of Western New York, 1994.

Renwick Gallery. *Skilled Work: American craft in the Renwick Gallery*. Washington D. C.: Renwick Gallery and Smithsonian Institution Press, 1998

Simpson, Tommy, and Lisa Hammel. *Hand and Home: The Homes of American Craftsmen*. New York: Bullfinch Press/Little, Brown and Company, 1994.

Smithsonian Institution. *A Picture Tour of the Smithsonian*.

Washington, D.C.: Smithsonian Institution Press, 1990.

Southworth, Susan, and Michael Southworth. *Ornamental Ironwork: An Illustrated Guide to its Design, History and Use in American Architecture*. Boston: David Godin, 1978.

Toledo Museum of Art. *Toledo Treasures*. New York: Hudson Hills Press, 1995.

Turner, Ralph. *Contemporary Jewelry: A Critical Assessment 1945-1975*. London, 1976.

Turner, Ralph. *Jewelry in Europe and America: New Times, New Thinking*. London: Thames and Hudson Ltd., 1996.

Untrauch, Oppi. *Jewelry Concepts and Technologies*. Garden City, New York: Doubleday, 1982.

Untrauch, Oppi. *Metal Techniques for Craftsmen*. Garden City, New York: Doubleday, 1968.

Verlag, Julius Hoffmann. *Kunst aus dem Feuer (Art from the Fire)*. Stüttgart: Hoffmann, 1987.

Waite, Diana S. *Ornamental Ironwork*. Albany, New York: Mount Ida Press, 1990.

Walking Tours of Downtown Rochester: Images of History. Rochester: The Landmark Society of Western New York, 1993.

Who's Who in American Art. New York: Jazues Cattell Press, 1975.

Willcox, Donald J. *Body Jewelry: International Perspectives*. Chicago, 1971.

Selected Periodicals Since 1990

"A Gundy Gathering." *Tyler Gestures*, Fall 1993.

Abercrombie, Stanley. "KPFIA: Investment Banking Offices a Laboratory for Studio Furniture Art." *Interior Design*, September 1995, Number 10, ill., pp. 136-141.

Adamson, Jeremy. "Albert Paley: Studies for the 'Portal Gate'." *Renwick Quarterly*, Sept., Oct., Nov., 1992., ill., pp. 1 & 4-5.

Adamson, Jeremy. "Albert Paley: Studies for the 'Portal Gate'." *American Art*, National Museum of American Art, Smithsonian Institution, Summer 1992., ill., pp. 6-13.

"Albert Paley at Temple Gallery." *Tyler Gestures*, Spring 1994, ill., p.1,3.

"Albert Paley: Jewelry Exhibit at The Renwick Gallery." *Antiques and The Arts Weekly*, January 1992, ill., p. 97, Section C.

"Albert Paley: New Sculptures." *Metalsmith*, Winter 1992, ill., pp. 14-19.

"Albert Paley: Organic Designs." *Temple Review*, Summer 1991, ill., p. 34.

"Albert Paley: Recent Works." *Harn Museum of Art*, May 1992, ill., pp. 4-5.

"Albert Paley: Sculptural Adornment." *Renwick Quarterly*, December 1991/January/February 1992, ill., pp. 1-2.

Alexander, Eric. "Victoria & Albert Symposium." *British*

Blacksmith, No. 73 (Winter 1995), cover feature, ill., pp. 4-5.

Alexander, Tom. "The Anvil Chorus is Ringing Loud and Clear Again." *Smithsonian Magazine*, May 1993, ill., pp. 47-59.

American Craft, April/May 1992, ill., p. 66.

American Craft, April/May 1993, ill., pp. 10-12.

American Craft, June/July 1993, ill., p. 77.

American Illustrated, (Russian publication), November 1991, ill., pp. 3, 56.

"Albert Paley, Art Complex Museum." *A-Plus*, June 1993.

"Appunti. Dal mondo, messaggi solari e design scultural-organico." *Casa Vogue*, April 1994, ill.

"Art, Crafts to Open Faculty Show." *RIT News and Events*, Vol. 25, No. 6, October 14, 1993, p. 1.

Athineos, Doris. "Home and Hearth." *Art & Antiques*, December 1993, ill., p. 37.

Backer, Noelle. "Albert Paley: In Transition & Progress." *Crafts Report*, September, 1996, ill., pp. 50-51.

Baran-Mickle, William. "An Interview with Lloyd E. Herman." *Metalsmith*, Spring 1994, Volume 14, Number 2, pp. 30, 31.

Bell, Jeannie Keefer. "Jewellery & Metalsmithing in the USA." *Craftwest National*, August 1992, ill., pp. 60-61.

Bell, Robert. "Design Visions." *Craft Arts International*, Issue 25, 1992, pp. 32, 34.

Bergmann, Meredith. "Albert Paley / Peter Joseph Gallery." *The New York Review of Art*, Volume I, Number 4, Summer 1994, p.18.

Berry, Heidi L. "The White House Crafts Collection." *AmericanStyle*, Fall 1995/Winter 1996, ill., pp. 40-47.

"Bill and Hillary Laud RIT Artists-in-Residence." *RIT News & Events*, Vol. 25, No. 12, January 27, 1994, ill., p. 1.

"The Blacksmithing Craft Continuum." *British Blacksmith*, No. 69, Fall 1993, p. 3.

Blankstein, Amy. "Commissions: Albert Paley, *Passage*, Asheville, North Carolina," *Sculpture Magazine*, February 1996, ill., p. 27.

Bolz, Diane M. "Albert Paley's Wearable Sculpture." *Smithsonian*, November 1991, ill., p. 202.

Bosomworth, Dorothy. "Conference Report V&A Ironwork." *Apollo*, January 1995, ill., p. 56.

Broadrup, Elizabeth. "Commissions." *Sculpture*, September/October 1991, ill., pp. 24-25.

Brown, Gail M. "Revolving Techniques: Clay, Glass, Metal and Wood." *Metalsmith*, Fall 1992, p. 45.

Brumback, Nancy. "Craft and Art Worlds Share Spotlight With a Pair of Events in Chicago." *Woodshop News*, December 1993.

Burch, Coralee. "Wild and Wonderful Art for Interiors." *Daka Magazine*, March 1990.

Burlin, Brenda J. "Four Modern Blacksmiths." *Metropolis*, March 1994, ill., pp. 38-39.

"Celebration Chicago." *American Craft*, December 1993/January 1994, ill., pp. 68-69.

Chatwin, Amina. "Fifty years of steel in art – part 2." *Steel Times*, October, 1998, ill., p. 373.

Chastain-Chapman, Tony, "Aspiring to History." *American Craft*, April/May 1988, ill., pp. 56-59.

"Chicago Design Show" *Interior Design*, August, 1998, ill., pp. 90-91

"Clyde's at Tyson's Corner." *Interior Design*, 1980, ill., p. 157.

"Commissions." *American Craft*, April/May 1990, ill., p. 88.

"Commissions." *American Craft*, August/September 2000, ill., p. 28.

"Craftworld." *American Craft*, August/September 1994, p.17.

Csaszar, Tom. "Fourteenth International Sculpture Conference." *New Art Examiner*, October 1992, pp. 42 - 44.

"Das grosste Treffen der Welt – Besuch bei ABANA." *Hephaistos*, 9/10, 1996, ill., p. 16.

DeAmicis, Ralph Mark. "The Master's Role in a Sculptor's Metamorphosis." *Maquette*, May/June 1995, p. 24.

Design Journal (Korean Publication), Issue 30, August/September 1990, ill., pp. 38, 39.

Destin, Jeanne. "Chronicle: Crafts, Classics, and Other Events in the South." *Southern Accents*, July-August 1995, ill., p. 127.

Deutsche Vogue, April 1993, ill., p. 112.

"Distinguished Professorships." *RIT News & Events*, December 7, 1995, Vol. 27, No. 7, p. 6.

Dreyer, Robin. "The Last Word." *Anvil's Ring*, Winter 1995-1996, p. 39.

Erikson, Dr. Dorothy. "Design Visions: Exhibitions of Contemporary Design and Crafts." *Craft Victoria*, October/November 1992.

Evans, James. "Albert Paley." *Kunsthandwerk*, (Norway), February 1995, ill., pp. 2-11.

"Events." *The Anvil's Ring*, Fall 1994, p. 55.

"Every Home a Museum." *House Beautiful*, July 1992, ill., pp. 48-49.

Fariello, Anna. "Albert Paley." *New Art Examiner*, April 1991, p. 41.

Friedlander, Rachel. "Critical Issues." *British Blacksmith*, No. 60, Autumn 1991, ill., pp. 28-31.

Gimelson, Deborah. "Manhattan Harmonies." *Architectural Digest*, March 1995, ill., pp. 165, 167.

"Glimpses Into the Creative Processes of Albert Paley." *Gallery Association of New York State Bulletin*, Fall 1994, Volume II, Number 1, ill., pp. 3-4.

Greco, Stephen. "Peter in Wonderland." *Avenue*, February 1994, pp. 14-17.

Hammel, Lisa. "Jewels in Modern Time, The Collection of Helen Drutt." *American Craft*, February/March 1994, ill., pp. 47-53.

Hammel, Lisa. "Metalwork in the 20th Century." *Metalsmith*, Fall 1994, p. 28.

"Hand and Home: The Homes of American Craftsmen." *American Craft*, August/September 1994, ill., p. 53.

Harmon, Eric. "My Reflections." *Anvil's Ring*, Fall, 1996, ill., pp. 19-20.

Harn Museum of Art, June 1992, Cover illustration.

Hensler, Kate. "Temple." *Interiors*, August 1995, ill., pp. 40-43.

Hillenkamp, Helmut. "Schaufenster: Albert Paley, Rochester, USA." *Hephaistos*, 11/12,1993, ill., p.15.

Hodik, Barbara. "Albert Paley: Positioned for the Nineties." *Anvil's Ring*, Summer 1990, cover feature, ill., pp. 10 -16.

Holliday, Kate. "Albert Paley: Scaled for Domesticity." *NOAR [New Orleans Art Review]*, September/October 1995, ill., pp. 32-34.

"Inspiration: 6 Metalsmith Masters Visit Korea This Summer." *Monthly Design*, June 1995, ill., pp.138-139.

Jubenville, Jeff. "Forging In Its Finest Form." *Fabricator*, July-August 1995, cover feature, ill., pp. 10-18.

Kangas, Matthew. "Albert Paley: Bryan Ohno Gallery." *Glass*, Summer 2000, ill. p. 55.

Kangas, Matthew. "Albert Paley at Peter Joseph." *Art in America*, November 1992, ill., pp. 136-137.

Kangas, Matthew. "Albert Paley: Organic Form." *Sculpture*, May 1999, ill. pp. 10-11.

Kemp, John R. " Albert Paley: Simonne Stern." *ARTnews*, September 2000, ill., p. 178.

Kernan, Michael. "A Storied Gallery." *Smithsonian*, September 2000, ill., pp. 22-25.

Kim Hongia-Park Inn-Seok. "Architectural Metalwork Designer Albert Paley." *Monthly Design*, 08 1995, ill., pp. 94-99.

"Kuriositäten 'Made in USA.'" *Hephaistos*, 9/10 1994, ill. p. 30.

Lee, Lanie. "Albert Paley: Reggiani Gallery, New York, NY." *Metalsmith*, Fall 1993, p. 4.

Lucie-Smith, Edward. "Sources of Inspiration." *Crafts* (United Kingdom Publication), May/June 1990, ill., pp. 46-47.

Magnusson, Emanuela Frattini. "Meccenate a N.Y." *Casa Vogue*, February 1994.

"Man of Steel." *Connoisseur*, January 1992, ill., pp. 93-94.

May, Ken. "Reflections on the 1995 Penland Iron Symposium." *Anvil's Ring*, Winter 1995-1996, ill., pp. 34-37.

McCall, Pete. "AIA Selects Eight for Institute Honors." *AIArchitect*, Volume 2, April 1995, ill., p. 21.

McCarthy, Cathleen. "Thoroughbred Collection" *Art & Antiques*, December 1998, ill., pp. 68-72.

"New York Artist Albert Paley...." *The Antique Collector*, December/January 1994/1995, Volume 66 No.1, ill.

Newcomb, Mary. "Breaking Barriers." *Albany Magazine*, (Georgia), September-October 1995, p. 32.

Nicholson, Vanessa. "Iron in the Soul." *The Antique Collector*, February 1995, p. 83.

"The 1994 American Craft Council Awards." *American Craft*, December 1994/January 1995, ill., pp. 42, 88.

"1994 Top Job Award Winners." *Fabricator*, May-June 1994, p. 29.

"1995 Top Job Awards Competition Winners." *Fabricator*,

May-June 1995, p. 29.

Northwest Compass Readings Magazine. Tualatin, Oregon, January 1992, ill., pp. 96-97.

Norton, Deborah L. "A New Aesthetic: Albert Paley." *Ornament,* Spring 1992, ill., pp. 3, 56-61, 101.

Owings, Robert. "Expressive Design in Iron." *Anvil's Ring,* Winter 1995-1996, ill., pp. 38-39.

"Paley Sculpture Update." *Arts Council News* [Roanoke, VA], Spring/Summer, 1994.

"Paley Tables." *The Anvil's Ring,* Winter 1993-1994, ill., pp. 14-15.

"Paley's 'Wedge' Placed Downtown." *RIT News and Events,* Vol 25, No. 6, October 14, 1993, p. 7.

Parkinson, Peter. "Expressive Design in Iron- A Penland Symposium." *British Blacksmith,* No. 76, p. 18.

Princenthal, Nancy. "Sculptural Concerns Contemporary American Metalworking." *American Craft,* April/May 1995, ill., pp. 46-51.

"Renwick Aids in Starting White House Craft Collection." *Renwick Quarterly,* March, April, May 1994, p. 3.

"Review: Albert Paley: Art Complex Museum, Duxbury." *A Plus,* June 1993.

Ross, Helen. "Design Visions." *State of The Art,* Issue 4, November 1992.

Ruhling, Nancy A. "Steel Appeal," *US Air Magazine,* May 1993, p. 42.

Saari, Michael. "SIU Workshop." *The Anvil's Ring,* Fall 1994, ill., pp. 32-33.

"Schaufenster: Albert Paley, Rochester, USA." *Hephaistos,* 1/2, 1997, ill., p. 23.

"Schaufenster: Albert Paley, Rochester (USA)," *Hephaistos,* 11/12, 1994, ill., p.18.

"Sculptural Concerns: Contemporary American Metalworking." *American Craft Museum Newsletter,* Fall 1994, p. 2.

Sfirri, Mark. "Exhibit Review." *American Woodturner,* June 1992, pp. 22-24.

Shafer, Kathryn. "Rochester's Albert Paley: Soliloquies in Steel." *Rochester Business Profiles,* May 1991, ill., pp. 48-52.

Shoja, Jafar. "Technique and Technology." *Anvil's Ring,* Winter, 1996/97, ill., pp. 20-21.

"'66 Albert Paley." *Tyler Gestures,* Fall 1995, Number 21, p. 10.

Snell, Ted. "In Conversation With: Albert Paley." *Craftwest,* Autumn 1993, ill., pp. 1, 8-9.

Southwest Art. June 1991, ill., p. 22.

Tamulevich, Susan. "Whither Public Art?" *Inform,* January/February 1991, ill., pp. 12-15.

"Tasmanian Artist-in-Residence." *Craft New Zealand,* Spring 1993, p.14.

"Thanks." *Art Scene,* December 1993 - February 1994, ill., p.1.

"The Second World Congress of Smiths: Aachen, Germany - 1991." *Anvil's Ring,* Fall 1991, p. 35.

The Society of Jewelry Historians - USA Newsletter. Spring 1992, pp. 9, 11.

"Traume in Metall Paley packt aus." *Hephaistos,* 1/2, 1997,

ill., p. 36.

"Top Job Gallery: '94 Gold Award-Furniture & Accessories Paley Studios Ltd., Rochester, NY." *Fabricator,* July/August 1994, 49.

VanDenburgh, Stacey. "Recent Works by Albert Paley." *Anvil's Ring,* Spring 1996, ill., pp. 26-32.

Victoria and Albert Museum Report of the Board of Trustees. April 1, 1992 - March 31, 1995, ill., pp. 18, 28.

"White House Collection Celebrates America's Crafts Tradition." *MAGazine,* Sept./Oct. 1995, ill. pp. 2-3, 8.

"Whither Public Art?" *Inform,* January/February 1991.

Zimmerman, Paul. "Imagepflege in Nordeuropa." *Hephaistos,* 7/8 1994, ill., p. 10.

"Zoom in Detail." *Ntizain,* [Greece], Autumn 1995, ill., pp. 8-9.

Selected Catalogues

A Decade of Craft. New York, New York: American Craft Museum, 1990.

Albert Paley: Age of Steel. Provo, Utah: Museum of Art, Brigham Young University, 1996.

Albert Paley: Baroque Modernism. New York, New York: Peter Joseph Gallery, 1992.

Albert Paley. Washington, D.C.: Maurine Littleton Gallery, 2000.

Albert Paley: Organic Logic. New York, New York: Peter Joseph Gallery, 1994.

Albert Paley: Recent Works. Gainesville, Florida: Samuel P. Harn Museum of Art, University of Florida, 1992.

Albert Paley: Recent Works. Santa Fe, New Mexico: Gerald Peters Gallery, 1990.

Albert Paley: Sculptural Adornment. Washington, D.C.: Renwick Gallery of the National Museum of American Art, Smithsonian Institution, 1991.

Albert Paley: Sculpture. New York City, New York: Barbara Fendrick Gallery, 1989.

Albert Paley: Sculptures. Philadelphia, Pennsylvania: Rosenwald-Wolf Gallery - Philadelphia College of Art and Design at The University of the Arts, 1992.

Albert Paley: The Art of Metal. Springfield, Massachusetts: Museum of Fine Arts, 1985.

Albert Paley: The Iron Aesthetic. Washington, D.C.: Fendrick Gallery, 1983.

Albert Paley: The Paradox of Iron. Washington, D.C.: Fendrick Gallery, 1982.

American Crafts 1977. Philadelphia, Pennsylvania: Philadelphia Museum of Art, 1977.

American Crafts '76. Chicago, Illinois: Museum of Contemporary Art, 1976.

American Jewelry Today. Scranton, Pennsylvania: Everhart Museum, 1975.

American Metal Work, 1976. Lincoln, Nebraska: Sheldon Memorial Art Gallery, University of Nebraska, 1976.

The American Table. Washington, D.C.: Fendrick Gallery, 1977.

Architectural Art: A Discourse. New York City, New York: American Craft Museum, 1988.

Art and Application. New York City, New York: Turbulence Gallery, 1993.

Art Against Aids. Washington, D.C.: National Art Against Aids, 1990.

Art That Works: Decorative Arts of the Eighties. University of Washington Press, 1990.

Art to Art: Albert Paley, Jim Dine, Therman Statom Respond to Toledo's Treasures. Toledo, Ohio: The Toledo Museum of Art, 1996.

The Associates of the American Craft Museum Benefit Auction. New York: American Craft Museum, 1987.

Baroque '74. New York: Museum of Contemporary Crafts of the American Crafts Council, 1974.

Breaking Barriers: Recent American Craft. New York, New York: American Craft Museum, 1995.

The Charles Rand Penney Collection: Twentieth Century Art. The Memorial Art Gallery of the University of Rochester, Rochester, New York, 1983.

Chicago International New Art Forms Exposition. Chicago, Illinois, 1993.

Collecting American Decorative Arts and Sculpture: 1971-1991. Boston, Massachusetts: Museum of Fine Arts, 1991.

Contemporary American Crafts. Philadelphia, Pennsylvania: Philadelphia Museum of Art, 1991.

Contemporary Furniture Makers of the American Northeast. Princeton, New Jersey: The Gallery at Bristol-Myers Squibb, October 12-November 17, 1991.

Contemporary Jewelry and Leather. Kentfield, California: College of Marin, 1978.

Contemporary Jewelry and Silversmithing. Mexico City: Universidad Nacional Autonoma de Mexico, 1975.

Copper 2: The Second Copper Brass/Bronze Exhibition. Tucson, Arizona: University of Arizona Museum of Art, 1980.

Craft, Art, and Religion, Second International Seminar Exhibition: Summer 1978. New York: The Committee of Religion and Art of America, Inc. for Smithsonian Institution, Washington, D.C., and The Vatican Museum and Galleries, Rome, Italy, 1978.

Decorative Metalwork in Architecture. Minneapolis, Minnesota: University of Minnesota, 1986.

Design is the Art of Our Time. New York, New York: Design Industries Foundation for AIDS/Metropolitan Home, 1988.

Design Visions: International Directions in Glass, American Jewellery and Metalwork. Perth, Australia: Art Gallery of Western Australia, 1992.

8th General Assembly and International Conference, Kyoto, Japan. New York: World Crafts Council, 1978.

The Eloquent Object. Tulsa, Oklahoma: The Philbrook Museum of Art, 1987.

Exhibition of Liturgical Arts. Philadelphia, Pennsylvania: Museum of the Philadelphia Civic Center, 1976.

Fendrick Objects Number 1. Washington, D.C.: Barbara Fendrick Gallery.

The First International Metal Art Workshop & Seminar. Iri City, Korea: Won Kwang University, 1995.

Five Modern American Masters. Cleveland, Ohio: The New Gallery of Contemporary American Art, 1983.

Five Visiting Artists. Pittsburgh, Pennsylvania: Carnegie-Mellon University, 1984.

Form, Function, Fantasy: The Craft Art Collections. Buffalo, New York: A Catalogue of The Charles Rand Penney Collection of Craft Art and Other Craft Art Collections at the Burchfield-Penney Art Center, Buffalo State College, 1995.

Forms in Metal/275 Years of Metalsmithing in America. New York: Finch College Museum of Art and Museum of Contemporary Crafts of the American Crafts Council, 1975.

Form '74. DeKalb, Illinois: Northern Illinois University, 1974.

Fourth Invitational Contemporary Crafts Exhibition. Saratoga Springs, New York: Skidmore College, 1975.

Functional Ornament: The Ironwork of Albert Paley. Iowa City, Iowa: University of Iowa, Museum of Art, 1983.

The Goldsmith. St. Paul, Minnesota: The Minnesota Museum of Art, St. Paul, 1974.

Goldsmithing Exhibition. Mexico City: Universidad Nacional Autonoma de Mexico, 1975.

Goldsmith '70. St. Paul, Minnesota: Permanent Collection Gallery, Minnesota Museum of Art, 1970.

The Guild. New York: Kraus-Sikes, Inc., 1987.

Homage to Art. Rochester, New York: NCECA, 1996.

Inspiration & Context: The Drawings of Albert Paley. Rochester, New York: Memorial Art Gallery of the University of Rochester, 1994.

Integration and Dialogue. Seattle, Washington: Riley Hawk Galleries, 2000.

International Jewelry Art Exhibition. Tokyo, Japan: Nihon Keizal Shimbun, 1976.

Invitational Crafts Exhibition. Albuquerque, New Mexico: The University of New Mexico, 1973.

Invitational Jewelry Exhibition. Pensacola, Florida: Pensacola Junior College, Visual Arts Gallery, 1975.

Iron, Solid Wrought/USA. Carbondale, Illinois: Southern Illinois University, 1976.

Jewelers, U.S.A. Fullerton, California: California State University, 1976.

Jewelry '71. Toronto, Canada: Art Gallery of Ontario, 1971.

Kanazawa Arts and Crafts Competition '91. Kanazawa, Japan, 1991.

Light Interpretations: A Hannukah Menorah Invitational. San Francisco: The Jewish Museum San Francisco, 1995.

Living in the Moment: Contemporary Artists Celebrate Jewish Time. New York: Hebrew Union College, 2000.

Masterworks Two. New York, New York: Peter Joseph Gallery, 1994.

Metal '74. Brockport, New York: State University of New York College at Brockport, 1974.

Metals and Fibers. Amherst, Massachusetts: University of Massachusetts, 1972.

Metals Invitational 1975. New Paltz, New York: State University of New York College at New Paltz, 1975.

Metals Invitational 1975. Richmond, Virginia: Anderson Gallery, Virginia Commonwealth University, 1976.

The Metalwork of Albert Paley. Sheboygan, Wisconsin: John Michael Kohler Arts Center, 1980.

National Invitational Crafts Exhibition 1976. Urbana-Champaign, Illinois: Krannert Art Museum, University of Illinois, 1976.

National Invitational Exhibition in Contemporary Jewelry. Atlanta: Georgia State University, 1974.

National Jewelry and Holloware Invitational. DeKalb, Illinois: Northern Illinois University, 1972.

New Art Forms. Chicago, Illinois: The Chicago International Exposition, 1988.

New Art in an Old City. New Orleans, Louisiana: The Virlane Foundation and The K & B Corporation Collections, 1990.

New York State Craftsmen: 1972 Selections. Albany, New York: State University of New York at Albany, Albany, New York, 1972.

1978 Metals Invitational. Oneonta, New York: State University of New York College at Oneonta, 1978.

1971 Rochester Finger Lakes' Exhibition. Rochester, New York: Memorial Art Gallery, University of Rochester, 1971.

1972 Rochester Finger Lakes' Exhibition. Rochester, New York: Memorial Art Gallery, University of Rochester, 1972.

Objects for Preparing Food. New York: Museum of Contemporary Crafts of the American Crafts Council, 1972-1973.

One-man Show. New York: Fairtree Gallery, 1973.

Paley/Castle. New York: Fairtree Gallery, 1973.

Paley/Castle. Ithaca, New York: Cornell University, Herbert F. Johnson Museum of Art, 1974.

Paley/Castle/Wildenhain. Rochester, New York: Memorial Art Gallery, University of Rochester, 1979.

Exhibition catalogue. Philadelphia, Pennsylvania: Tyler School of Art, Temple University, 1974.

Pilchuck 20th Anniversary Glass Auction. Seattle: Pilchuck Glass School, 1998.

Precious Metals. Coral Gables, Florida: Lowe Art Museum, University of Miami, 1975-76.

Public Art Proposals. Yokohama, Japan: International Contemporary Art Fair, 1992.

Schmuck Unserer Zeit, 1964-1993, Sammlung Helen Drutt, USA [Jewelry of our Time, Helen Drutt Collection]. Zürich, Switzerland: Museum Bellerive, 1994.

Sculptural Concerns: Contemporary American Metalworking. Cincinnati, Ohio: The Contemporary Arts Center, 1993.

Second Annual Craft Invitational. DeKalb, Illinois: University Center Gallery, Northern Illinois University, 1970.

2nd Annual Jewelry Invitational. Ellensburg, Washington: Central Washington State College, Fine Arts Gallery, 1976.

Second Invitational Contemporary Crafts Show. Saratoga Springs, New York: Skidmore College, 1971.

Seventh Biennial National Invitational Crafts Exhibition. Normal, Illinois: Center for the Visual Arts Gallery, Illinois State University, 1978.

Smithing '73. Brockport, New York: State University of New York College at Brockport, 1973.

SNAG, Jewelry and Metal Objects from the Society of North American Goldsmiths. Pforzheim, Germany: Schmuckmuseum Pforzheim, 1979.

Sotheby's: Contemporary Works of Art. New York: 1992.

"Symbolism and Imagery." *1975 Jewelry International.* Ellensburg, Washington: Central Washington State College, Fine Arts Gallery, 1975.

Tendencies—1970: Art in Gold and Silver. Pforzheim, West Germany: Schmuckmuseum um Reuchlinhaus, 1970. Exhibition catalogue. Terre Haute, Indiana: Indiana State University, Turman Art Gallery, 1975.

3rd Annual National Exhibition in Contemporary Jewelry. Atlanta: Georgia State University, 1976.

Towards a New Iron Age. London: Victoria and Albert Museum, 1982.

25th Anniversary Exhibition. Rochester, New York: Rochester Institute of Technology, School for American Craftsmen, 1975.

Tyler Directions 71. Philadelphia: Museum of the Philadelphia Civic Center, 1971.

Tyler Profile '72. Philadelphia: Museum of the Philadelphia Civic Center, 1972.

The Tyler Years/Lechtzin, Staffel, Viesulas. Philadelphia: Tyler School of Art, Temple University, 1973.

20th Century Decorative Works of Art. Hong Kong: Sotheby's, New York, 1999, pp. 66-67.

World Competition of Arts and Crafts Kanazawa '99. Kanazawa, Japan: Executive Committee of the World Competition of Arts & Crafts Kanazawa '99, 1999, p. 5 (juror section).

World Contemporary Craft Now. Korea: organizing committee of Chougju International Craft Biennale, 1999, pp. 114-115.

Yale University Art Gallery Bulletin 1991. New Haven, Connecticut: Yale University Art Gallery, 1991, p. 111.

Year of American Craft... in Celebration. Ames, Iowa: Iowa State University, Brunnier Art Museum, 1993.

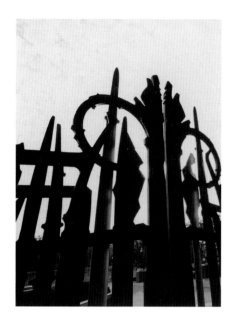

FLORIDA STATE UNIVERSITY

Talbot D'Alemberte
President
Lawrence G. Abele
Provost & VP for Academic Affairs
J.L. Draper
Dean, School of Visual Arts & Dance

MUSEUM STEERING COMMITTEE

Kabuya Bowens
Associate Professor of Art
Ray Burggraf
Associate Chair, Department of Art
David Butler
Chair, Interior Design
Paula Gerson
Chair, Art History
Janice Hartwell
Associate Professor of Art
Brenda Jordan
Assistant Professor of Art History
Sally McRorie
Chair, Art Education
Roald Nasgaard
Chair, Department of Art
Allys Palladino-Craig
Director, Museum of Fine Arts
Libby Patenaude
Chair, Department of Dance
Jeffrey Spalding
Director, Appleton Museum of Art
William Walmsley
Professor Emeritus, Art

MUSEUM OF FINE ARTS STAFF

Allys Palladino-Craig
Director
Viki D. Thompson Wylder
Curator of Education
Jean D. Young
Registrar / Fiscal Officer
Becky Jones
Coordinator, Appleton Projects
Wayne Vonada
Preparator
Jung Yul Kimbrell
Sara Klein
Preston McLane
Elena Shkvarkina
Marian Wooten
Graduate Assistants

VOLUNTEERS AND INTERNS

Miguel Amador	Emilly Foster
Holly Barlow	Yesi Hernandez
Shawn Bland	Jason Jay-Peterson
Julie Bohannon	Veronika Knierim
Kim Brazerol	Adrienne Lee
Meghan Burkhart	Melissa Ray
Beth Carver	Amanda Reed
Yi-Chien Chen	Renee Reinfrank
Sara Chumbley	Michela Restina
Reed Craig	Clint Riley
Ashley Cross	Alexis Rodriguez
Katherine McDonald	Amanda Stepp
Kathi McFarland	Jessica Streiter

James Sweeney, Volunteer Coordinator
2000-2001
Matthew Fenner, Volunteer Coordinator
2002

Above and back cover: *Florida State University Center Gates*, formed and fabricated steel, stainless steel, and bronze, 423 x 7 x 150 inches. Collection: Florida State University, Art in State Buildings Program, State of Florida, installed April 29, 1999. (Photograph: Bill Langford)